Photos with
IMPACT

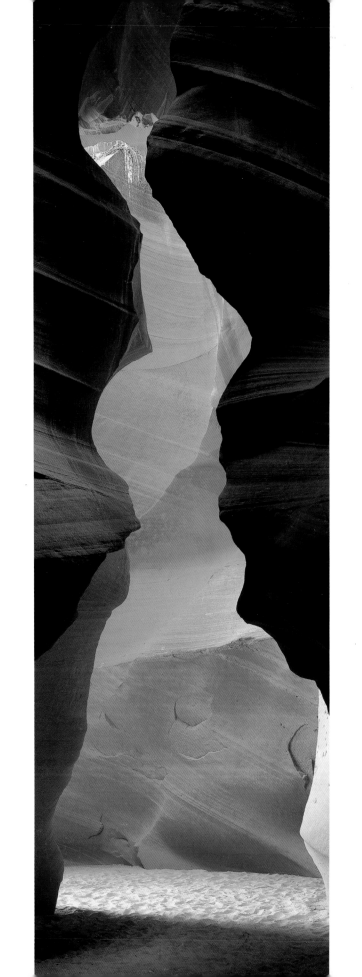

Photos with
IMPACT

TOM MACKIE

David & Charles

To my sister Connie, whose support and belief in me made this book possible;
without her, I wouldn't have been a photographer

A DAVID & CHARLES BOOK

First published in the UK in 2003

Copyright © Tom Mackie 2003

Distributed in North America
by F&W Publications, Inc.
4700 East Galbraith Road
Cincinnati, OH 45236
1-800-289-0963

Tom Mackie has asserted his right to be identified as the author
of this work in accordance with the Copyright, Designs and Patents
Act, 1988.

A catalogue record for this book is available from the British Library.

ISBN 0 7153 1505 6 hardback
ISBN 0 7153 1506 4 paperback (USA only)

Printed in China by Leefung-Asco Printers
for David & Charles
Brunel House Newton Abbot Devon

Senior Editor Freya Dangerfield
Associate Writer Kate Salway
Executive Art Editor Ali Myer
Production Controller Kelly Smith

Visit our website at www.davidandcharles.co.uk

David & Charles books are available from all good bookshops;
alternatively you can contact our Orderline on (0)1626 334555 or
write to us at FREEPOST EX2110, David & Charles Direct, Newton
Abbot, TQ12 4ZZ (no stamp required UK mainland).

Previous page

Upper Antelope slot canyon, Page, Arizona, USA

The various tones and sculpted shapes make this sandstone slot
canyon an ideal subject for abstract form. This particular canyon
has become so popular with tourists that it provides a challenge to
make photographs without someone tripping over your tripod. A
momentary blockade from my friend allowed me to get this picture.
Fuji GX617 panoramic; 180mm lens; Fuji Velvia

Opposite

Daffodil path, Keukenhof Gardens, Lisse, Holland

One of the problems with photographing gardens that are open to
the public is the amount of time it takes to get the right shot. By the
time I discovered this path it was teaming with visitors. I must have
waited over an hour before the scene was completely clear of
people, but I felt the composition and colours were worth waiting for.
Fuji GX617 panoramic; 90mm lens; Fuji Velvia

contents

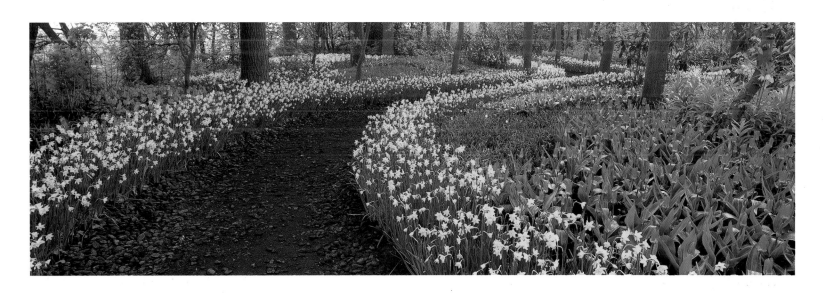

introduction

There is always something new to learn in photography, and this is one of the reasons why it has an endless fascination for me. The day that I stop learning I may as well hang up my camera. I never tire of finding out about new equipment or techniques and, especially now with rapidly moving digital technology, there always seems to be some exciting new development. Even though, in writing this book, I set out to communicate how I work, it has nevertheless been a learning experience for me. I have found out about my own thought processes and the way I go about making photographs – things that I normally take for granted.

This book is not intended to be a technical manual. You will not find explanations about aperture, shutter speeds and focal lengths, as these are details that I consider secondary to the image. Getting a correct exposure is important, but creating a powerful image is paramount, and it is this aspect of my work that I have concentrated on.

Impact can be achieved in innumerable ways. A photograph with real impact might be hard-hitting visually, with boldly contrasting colours in a very pared down composition – an architectural detail, for example. But a spectacular landscape with beautiful, natural

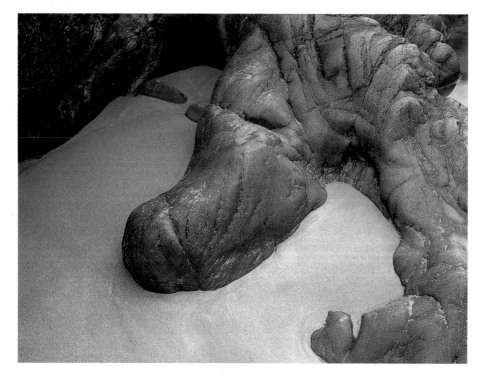

Beach abstract, Connemara, Ireland
Different viewpoints present you with unusual or abstract images that take your photograph beyond the ordinary. The shape of this rock reminded me of an old, wrinkled thumb and forefinger. I composed it to emphasize the balance between the negative space of the sand and the positive space of the rock.
Wista Field 4 x 5; 210mm lens; Fuji Velvia

California poppies and flowering flax, East Ruston Old Vicarage Garden, Norfolk, England
Contrasting colours and close-up detail are key components of a strking photograph. I chose to photograph these flowers from ground level to put the vibrant reds and oranges against the deep blue sky. This emphasized the complementary colours and omitted any confusing background.
Pentax 6 x 7; 45mm lens; polarizing filter; Fuji Velvia

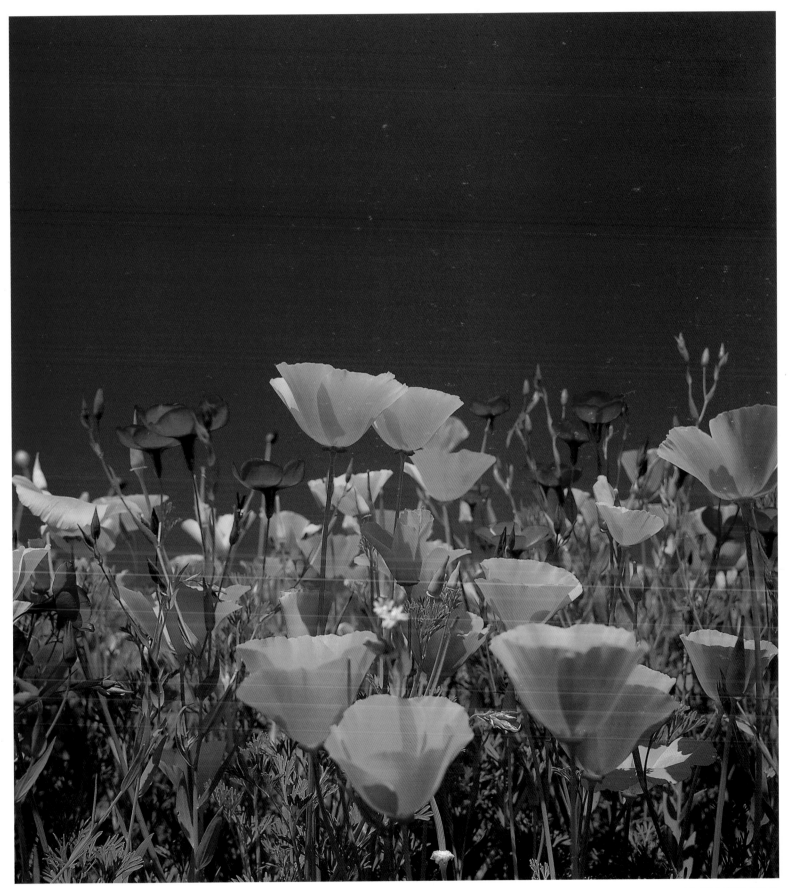

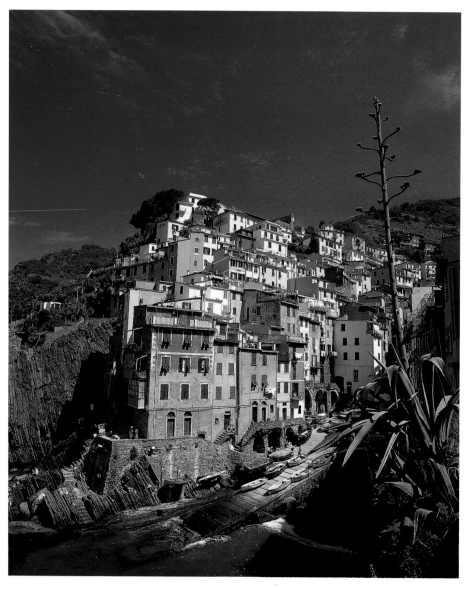

Riomaggiore, Cinque Terre, Liguria, Italy
The five villages of Cinque Terre each have their own unique
characteristics, and the patterns and pastel colours of the buildings
provide endless photographic possibilities. The way the village of
Riomaggiore is stacked on the cliffside gives an unusual forced
perspective when photographed with a wide-angle lens.
Pentax 6 x 7; 45mm lens; polarizing filter; Fuji Velvia

colours and a feeling of grand perspective, care-fully
composed to create visual harmony, can also have great
impact on the viewer. Creating photographs with impact
is not only satisfying as a photographer, but
essential if you want to sell your images, so I also discuss
what makes an image more marketable.

Even though I had a thorough schooling in photo-
graphy, one thing they didn't teach me was how to 'see'.
To a great extent, I think this cannot be taught. Every
photographer has his or her own unique way of seeing; if
you put a dozen photographers in the same location,
chances are the result will be a dozen very different
images. By explaining how I try to see beyond the everyday
in my search for interesting and original images, I hope I
have provided some suggestions that will help you find
your own unique compositions. This is really the
central thread running through this book: how to 'see'
a great photograph, and how to arrange it in the picture
frame and maximize its impact through intelligent use
of lighting, colour, filtration and even, in the right
circumstances, digital manipulation.

If there was one single tip that I could give to help
achieve these goals, it would be: never be complacent with
the first image you take. When faced with a particular
subject I always ask myself, how can I improve on this?
Is there anything I can do differently to make it stronger?
You may have taken a great image already, but if you
discipline yourself to think how it could be improved, you
will find yourself doing a lot of the things that I advocate
in this book: trying different compositions, changing your
point of view, coming in close, returning to the same
spot at different times of the year and in different light
and weather conditions. A small change can make a
big difference.

I have not set out to encourage anyone simply to do as
I do, but to explain how I work and how I have achieved

impact in my own images. I hope this will guide and encourage you to apply some of the principles to your own photography and put a new perspective on the way you look at the world. If you learn just one technique that improves your photography from this book, then it will have been worth it. But ultimately nothing can replace the experience you gain by spending as much time as possible out there creating images.

Tufa formations, Mono Lake, California, USA
I had been photographing the formations at sunrise and sunset over a period of three days. On the last morning, the conditions were better than the previous mornings, with a clear sky and a pink glow at the horizon. The lighting was soft, revealing detail in the tufa formations. I wanted to darken the top part of the sky to create a nice gradation. I used a softly graduated neutral-density filter because of the tufa spires rising above the horizon. A hard grad has a more definitive transition and would have darkened the spires too much. Pentax 6 x 7; 45mm lens; 0.6 neutral-density soft graduated filter; Fuji Velvia

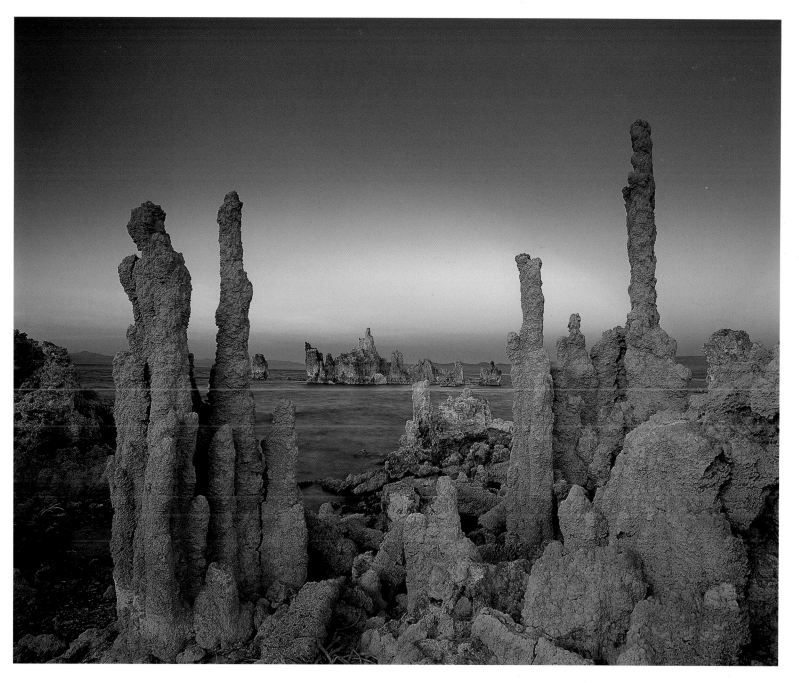

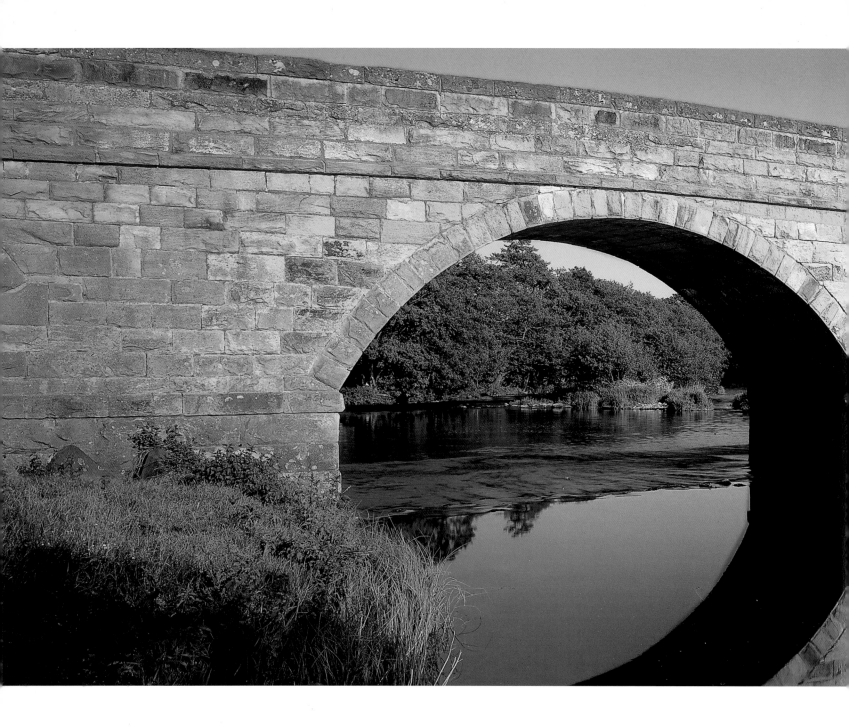

seeing the picture

Bridge and sheep, Northumberland, England

Ordinary subjects can become interesting images. By opening your mind to the visual elements of a scene, strong compositions result. Instead of looking at a scene for what it is, try 'seeing' the underlying elements that caught your attention in the first place. The reflections of the arches creating circular shapes attracted me to this image. I tried a few different angles initially, but found that this one accomplished my intentions. The sheep looking through the last arch completes the picture.

Fuji GX617 panoramic; 180mm lens; polarizing filter; Fuji Velvia

To take a photograph that has real impact, you need first to see the picture in your mind. The task of the photographer is to take the millions of visual stimuli our eyes are bombarded with on a daily basis and refine them down to ideas and then images that are so compelling that they capture the viewer's attention. This does not necessarily involve travelling to the most spectacular natural beauty spots or the world's most famous buildings – there is ample subject matter wherever you look. The trick is to learn to recognize it.

The camera, unlike the human eye, is not able to be selective; everything in the viewfinder has equal status. So it is up to the photographer to select or organize. You can develop this skill by looking more deeply into your chosen subject to discover exactly what it is about it that attracts you. Practice enables you to ignore the unimportant elements and see through them to the essence of the picture you wish to create. You can then exclude aspects that diminish, rather than add to, the power of the image, and so bring order to the composition. What you decide to omit from a composition is as important to the end result as what you decide to retain. In my work this usually means simplifying the image down to its basic details.

Personally, I prefer images that are straightforward and uncluttered. I always find myself searching for strong graphic elements that I can focus on within a scene. Too many elements within the picture frame confuse the viewer as to the photographer's intention, and dilute the overall impact of the image. What I look for are elements that constitute essential character and mood.

The endless and rapid technical developments are an exciting and ever-changing part of photography. It is easy to become absorbed in the choice of cameras and lenses, tripods, different film types, filters, lights and processing techniques, let alone digital technology. But although there is great satisfaction to be gained from mastering these tools, and it is vital to know the possibilities and limitations of your equipment, it is ultimately the ability to see the picture that produces a photograph with impact. The finish or the print quality of a photograph is

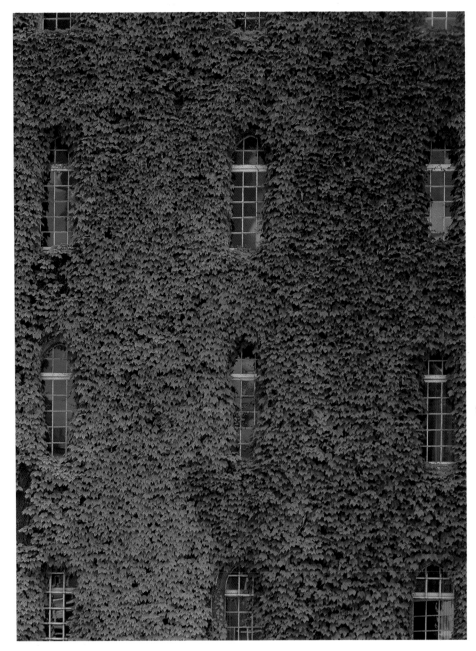

Ivy-covered wall, Cambridge, England
Images like this one in Cambridge are passed by daily without being noticed. The tight crop on the delicate patterns of the ivy leaves surrounding the windows presents an interesting slant on the architecture. I used the 4 x 5 to keep the lines of the windows vertical without converging. A polarizing filter removed the reflections from the leaves to increase saturation.
Wista Field 4 x 5; 210mm lens; polarizing filter, Fuji Velvia

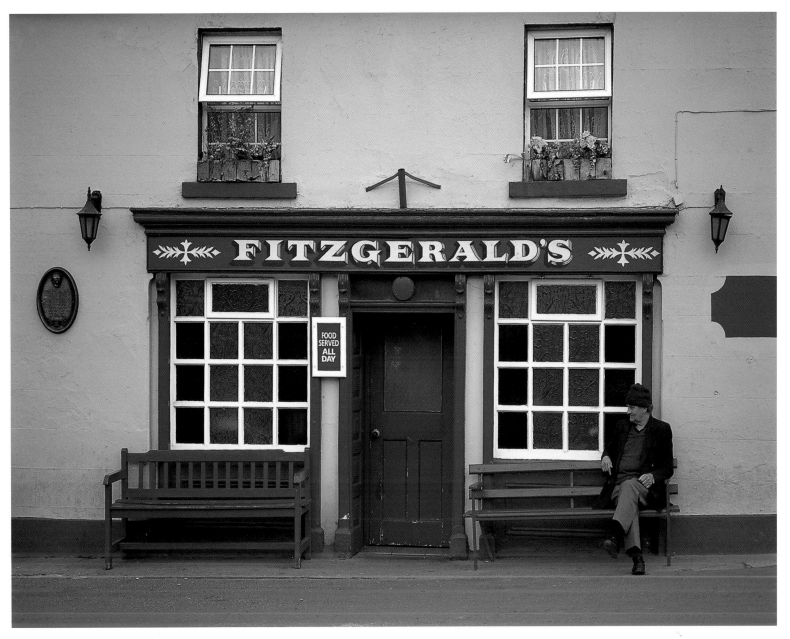

Avoca pub, Co. Wicklow, Ireland

The contrasting colours and graphic shapes of the windows of this pub caught my eye. Including just the local man proved to be more difficult as tourists dressed in shorts and T-shirts kept sitting on the benches. But, through much persuasion, they stood out of view to allow me to get the picture.

Pentax 6 x 7; 200mm lens; Fuji Velvia

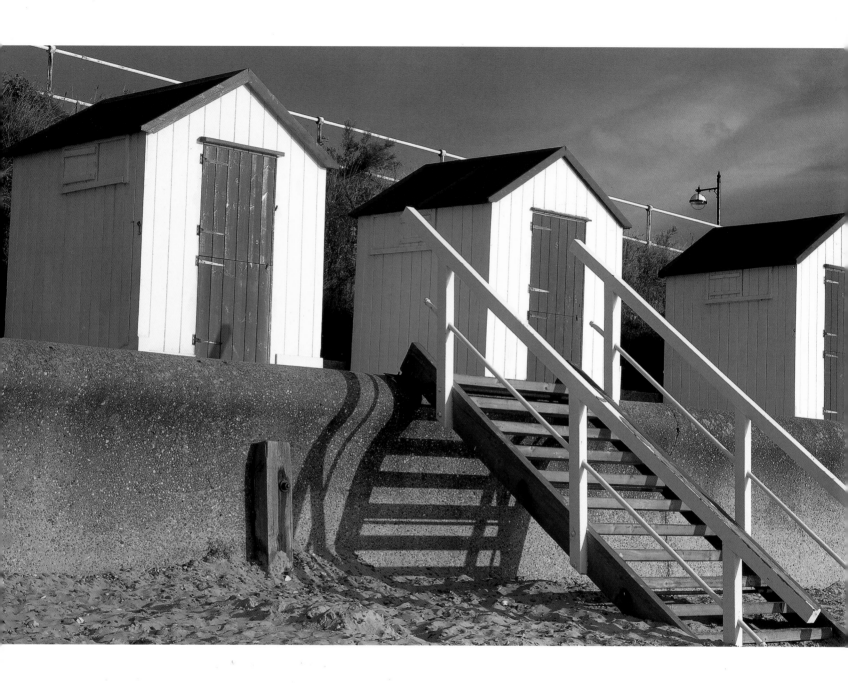

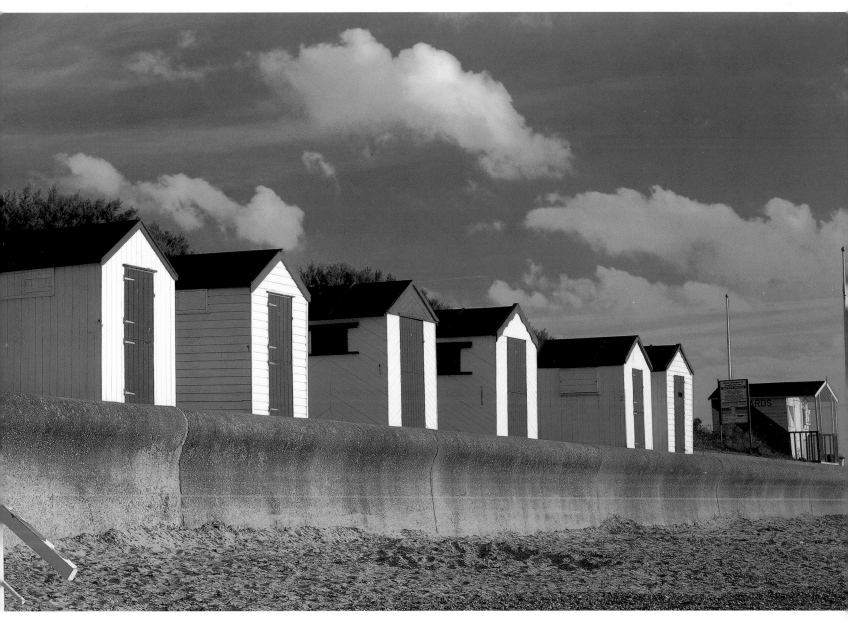

Southwold beach huts, Suffolk, England

I chose a low angle so that the pattern of the rooftops was against the sky. It took several attempts to get the first light on the huts because of the weather conditions. The panoramic format was ideally suited for this image as it allowed me to concentrate solely on the huts, without including any extraneous elements.

Fuji GX617 panoramic; 180mm lens; Fuji Velvia

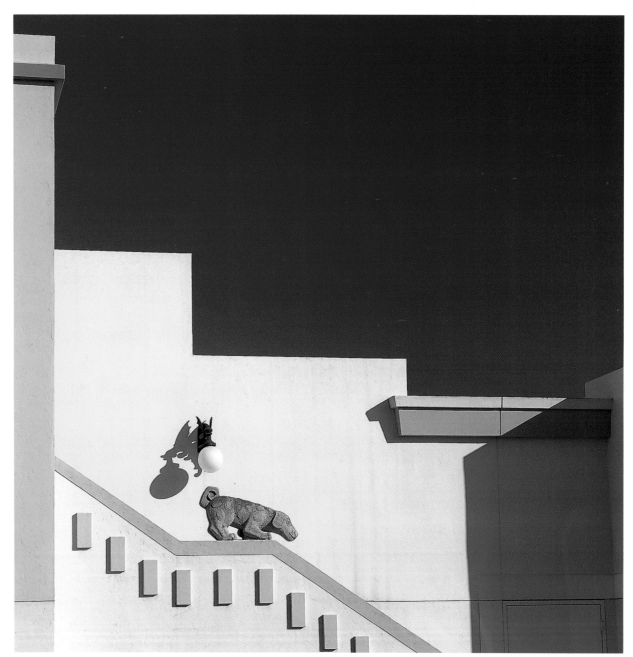

The Mercado, Phoenix, Arizona, USA

Initially, I made a picture of a section of the building (left). I liked the strong Southwestern colours and design, but the composition didn't feel quite right. The shadow on the right was too dominant and the balance between the sky and building was wrong as the sky had no integral part in what I wanted to bring across in the composition. Coming in tight with a 250mm lens (opposite) improves the composition by excluding everything that is distracting in the first image and concentrating purely on the diagonals and shapes.
Hasselblad 500C/M;150mm lens (left), 250mm lens (opposite); polarizing filter; Fuji Velvia

secondary to its idea, which is why technical advances do not make it easier to produce effective images. Technology is simply another tool of creativity. It is the ability to recognize a picture, to select and organize from the world around you and to really *look*, that is paramount.

LINE AND COLOUR

Line and colour are the two basic components that make up a picture. Lines are the building blocks of an image, but it is colour that sets the mood. Together, they are the elements to look for in recognizing potential compositions.

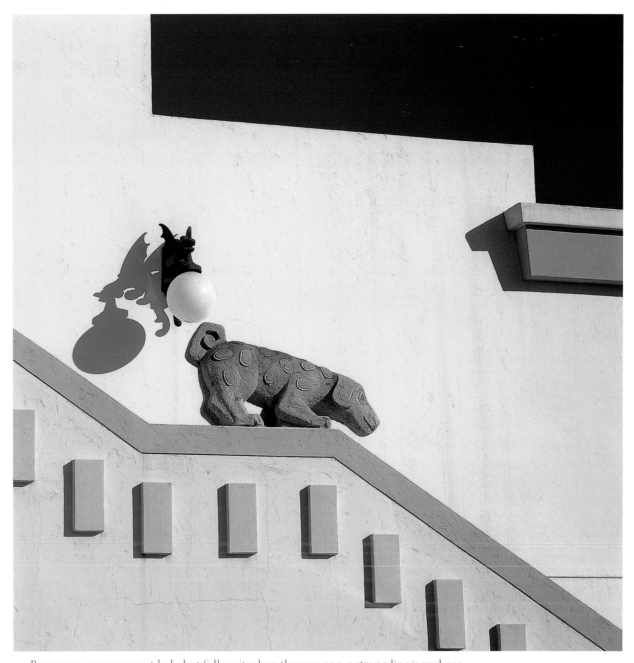

Because our eyes cannot help but follow it when they see one, a strong line is perhaps the most powerful element in a composition. You are not just looking for straight lines, but curves, S-shapes, triangles and rectangles. They exist everywhere in the form of roads, paths, fences, rivers, rows of crops or lines of telegraph poles. They can be used to guide the viewer through a scene, or to draw attention to a subject, directly or indirectly. Vertical lines, like trees or pillars, suggest strength, while horizontal lines (very often, literally the horizon) suggest calmness and passivity, and diagonal lines, like the furrows of a field, bring a feeling of liveliness and dynamism. A single line winding through an image, such as a woodland path, determines how the whole is perceived, and the colour

and tonal contrast of that line will add to its emphasis. A dominant line can simplify an image and clarify an over-complex scene by linking together its components.

The dominant diagonal line of the staircase in the photographs of the Mercado building in Arizona (see pages 16 and 17) is perhaps the simplest example of line at work in a composition. The Mercado has overhead midday light, and I used a polarizing filter to darken the sky in order to heighten the softness of the building's colours, giving a strong light/dark contrast. In the first image there are too many elements – a distracting shadow bottom right, a length of building down the left side and too much sky. So, even though there are clear lines and bold colours, the composition is not all that strong. Focusing in tighter, the second shot eliminates the three distractions: the colour is now starker, the line of the stairway is now much stronger and dominantly leads the eye to the carved dog, which has become more solidly the subject of the picture, and in general the image is much more powerful.

The close-up picture of the town of Casares in Andalucia (opposite) is an example of a highly complex use of line. There is not really a 'line' at all in the picture, certainly not a single one, but rather a latticework of lines that adhere to an overall pattern. Repeating patterns can be very powerful and stimulating to the eye. For this reason I have found that images using repeating patterns are often quite successful for me commercially, attracting use in media and advertising. For more on the use of line, see pages 69–72. The pictures of both the Mercado building and Casares also show how tightening up the composition gives it more impact; for more details on shooting close-up, see page 30.

The impact of colour in an image can be as subtle as the various changing hues of golden ears of wheat as a current of wind blows across the tops, or as apparent as a vibrant spring flower bed of yellow daffodils backed by

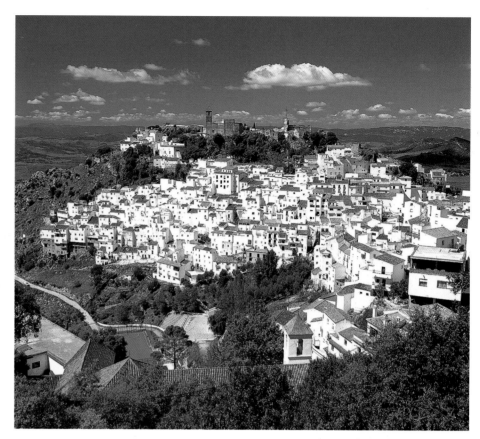

crimson-red tulips. Often just a small hint of colour against a monochromatic background is all that is needed to give impact to an image.

The two shots of Casares on these pages illustrate how the use of colour can affect an image. The first shot (above) is a typical picture-postcard view, sunny and inviting. There is nothing wrong with that; such an image may turn out to be a very useful stock photograph to have in my library, but it does not really have a great deal of impact. For the second shot (opposite), I made the decision to eliminate all of the sky and close in on the roofs of the houses from a high viewpoint, using morning light to give the scene a strong colour and a cold and crisp feeling. What that creates is an intriguing and fairly regular patchwork of white blocks and terracotta rectangles plus one singular, carefully positioned, patch of green in the right-hand third of the frame, which is what I think gives the image its three-dimensional character.

Casares, Andalucia, Spain

This viewpoint (opposite) is a classic view of this Spanish hilltop village, but I could see that there was a more interesting picture by changing my viewpoint. I got as close as I could while maintaining a high angle and used a telephoto to isolate the tile roofs (below).
Pentax 6 x 7; 45mm lens (opposite), 200mm lens (below), Fuji Velvia

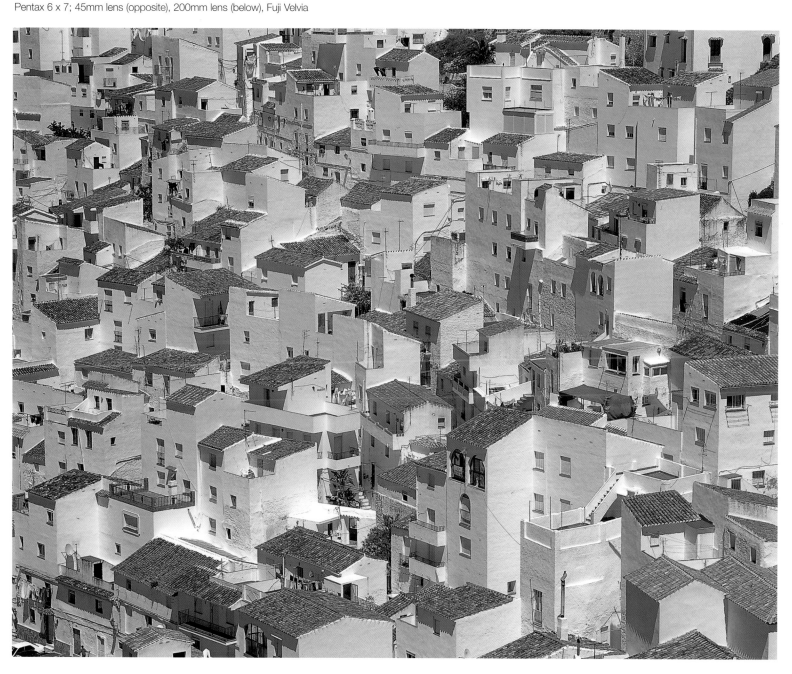

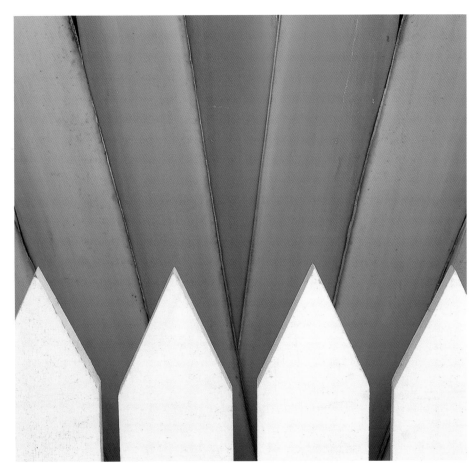

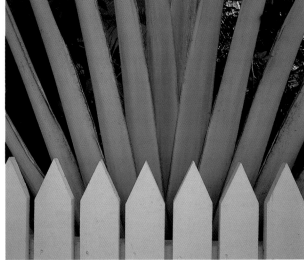

Picket fence and palm, Key West, Florida, USA

What impressed me most here was the array of tropical landscaping in some of the gardens. The juxtaposition of the white pickets of the fence and the patterns of the palm created a contrast between natural and man-made. I started with the wider view (above). After trying several shots, I ended up eliminating all background detail (left); this close-up image draws the eye to the deep overlapping V-shape coming down between the uprights of the fence.

Pentax 6 x 7; 135mm macro lens (left), 75mm lens (above); Fuji Velvia

ISOLATING DETAILS

Like the Andalucian village, your best picture of a subject may be hidden within the scene. I find making images like this, that isolate details from the broader view, both creative and challenging, and it can often take considerably longer to execute them. Composing the elements within the frame takes more exact placement if the overall image is going to be effective. Shooting with a mid- to long telephoto lens works well in isolating objects by flattening perspective, and allows me to work at a reasonable distance. I make sure that the focus plane is parallel to the lens plane so that the subject is in sharp focus right across the image, or I stop the lens down to increase the depth of field.

Whether it is repetitive pattern, striking colour or exciting forms and graphic shapes that attract me to make such photographs, I usually won't stop with the first image, but continue refining it, either by changing the angle slightly, or coming in even closer. The two images on this page of a picket fence and palm show how you can experiment even with just two ingredients.

It is possible to create images that effectively sum up a place without resorting to famous views or popular landmarks; small but well-observed details can be equally

powerful. The mention of Venice for most people conjures up images of the Grand Canal, the Rialto bridge or St Mark's cathedral. But a shot of an intimate yet familiar detail of a place can be just as telling. When I was photographing in Venice, I persuaded a gondolier (which was not easy!) to lend me his hat. I placed it in his gondola on the chair, which had traditional brass statues around it and was painted in black and gold, and took a few quick shots (right). This simple but easily recognizable shot turned out to be quite a successful image for me commercially, and has been used in some travel company brochures.

The American photographer Dewitt Jones once took a group of students to photograph Hawaii. Once there, they were understandably raring to go and discover the magnificent scenery of the island, but instead, he set them the task of coming up with the most creative image they could in the hotel car park. This meant they had to think about constructing a worthwhile image by looking more deeply into basic and normally overlooked details. This sort of exercise is a great discipline for training yourself to recognize the patterns, colours and small motifs that can

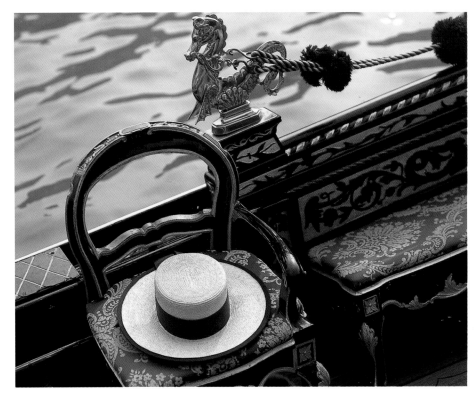

Gondolier's hat, Venice, Italy
It was a dull, overcast day during the Carnivale, so the classic iconic images of Venice were not possible. Instead, I concentrated on details that still gave a sense of place. I thought the ornate gondola statues would make an interesting subject, but the image needed another element to complete the story: a gondolier's hat.
Pentax 6 x 7; 75mm shift lens; Fuji Velvia

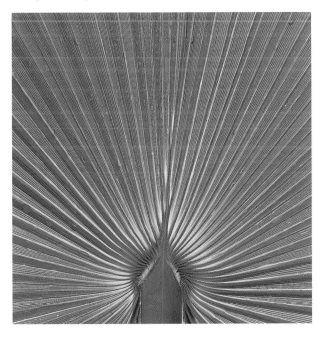

Palm fan close up
I exaggerated the angles of this fan palm by using a wide-angle lens and coming in close. The ridged form was made more apparent by back lighting the palm leaf.
Pentax 6 x 7; 45mm lens; Fuji Velvia

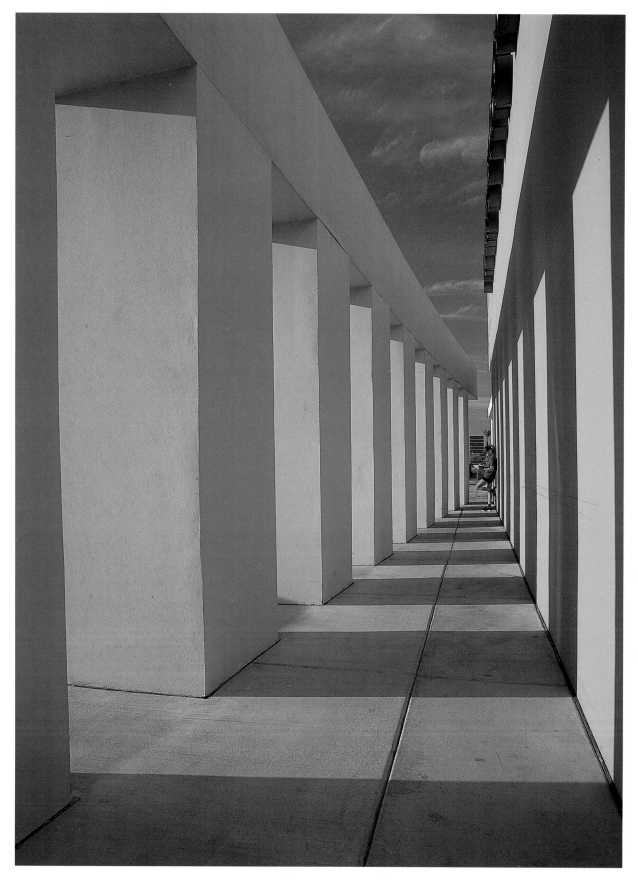

Descending columns, Phoenix, Arizona, USA

Timing was essential to get the rectangular-shaped shadows in the correct position on the wall. If it had been shot earlier with the sun higher, the shadows would have been lower on the wall and not so symmetrical. I placed my niece at the end of the row of columns to give the eye a stopping point and the image human scale.

Pentax 6 x 7; 75mm shift lens; polarizing filter; Fuji Velvia

give the essential flavour of a place, and make striking images in their own right.

Once this kind of thinking is part of you, you can never turn it off. I find myself looking for compositions in everything. The palm fan on page 21, for example, is a close-up image of one of four huge trees that I have to trim in my mother's garden in Phoenix. I cropped the shot so that the palm filled the frame to give a sense of it radiating out from its centre. It was backlit to emphasize the rich colours and slight curves in its form. This is an easy shot to do and has instant impact. It can also work well, shot much closer-up, with broadleaved foliage, such as horse-chestnut, where the back lighting would make the colour glow and reveal the intricate pattern of veins within the leaf.

THE BUILT ENVIRONMENT

In trying to see the picture in the man-made environment, you will often find strong, graphic lines. Some powerful photographs will present themselves very easily; others you may have to look harder for. Creative architects have obviously given a great deal of thought to line, pattern, space, balance and colour when designing their structure, and for the photographer it is a matter of understanding these elements and using them to compose an effective image by exploiting angles and views. But to give your photographs of buildings impact, or something more than a representation of the original, however striking and inventive it is, you must again look more deeply.

Buildings tend to be seen from a limited number of points of view. We usually approach a building along the road or path that leads to it, from the front, and directly to the entrance. This means that we will see it from those viewpoints only; if we approach from the side, or stop at the gate and look left or right, we might see something else entirely. This is what happened when I walked out of

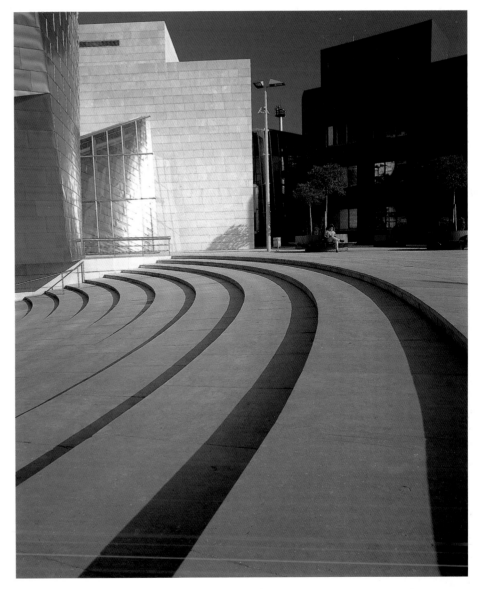

the front door of a bookshop in Phoenix (opposite). I came back with my gear to photograph these columns and many people, who had probably passed that way hundreds of times, asked what I was doing. Quite a few commented on the incredible light and design of this view that they had never noticed before.

Rather than photographing a building in its entirety, I find that concentrating on sections often creates more impact in the final shot. A series of such powerful images can interpret a building in a more interesting way than trying to cram the whole façade or outline into one. When I contemplate which elements to put together to

Guggenheim Museum, Bilbao, Spain

Photographing late in the day created long shadows from the steps. Using a wide-angle lens from a low angle accentuated the long, sweeping patterns leading to the building.
Pentax 6 x 7; 45mm lens; polarizing filter; Fuji Velvia

create an image of a piece of architecture, I am breaking the image down into its simplest forms, discarding all the extraneous details and concentrating only on essential colour and shape.

Photographing in Bilbao, Spain, I found that the steps to the Guggenheim Museum were an interesting design, leading the eye in a curve towards the building, and so focused on these (see page 23). Another example of choosing to see from a different point of view, this shot contains just enough of the Guggenheim to tell you which building it is – the familiar titanium walls in the top left corner of the image – but the dynamic element in the picture is undoubtedly the sweep of the steps rather than the celebrated building.

I came across the remarkable building of the Roanne Library as I was on my way to Provence in southern France. Not only is it built on the theme of a ship at sea, but the whole site is designed to have the buildings interact with each other in an original and inspiring way. It is a rare example, by Jean-Louis Godivier, of what you might call organic architecture, like the work of the Spanish architect Antonio Gaudí and the designer of Bilbao's Guggenheim, Frank Gehry, in which architects break the traditional and funda-mental rules of keeping straight lines in their buildings. This architectural style actually made it easier to photograph the library as I didn't have to worry about compensating for the effect of converging verticals. (This was just as well as I didn't have the time to set up

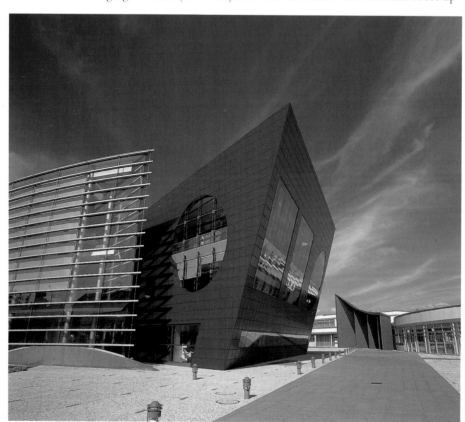

Library, Roanne, France

This is a good example of an architect breaking all the rules in an effective way. There are no straight vertical lines in the building so the distortion caused by using a wide-angle lens didn't matter as much. I used the path as a lead-in line and a polarizing filter to emphasize the clouds emanating from the buildings.
Pentax 6 x 7; 45mm lens; polarizing filter; Fuji Velvia

**Campo Volantin footbridge,
Bilbao, Spain**

The various lines and shadows
of this footbridge all converge
to draw the eye into the scene.
A lot of people were crossing
the bridge, but I chose to
include only one person in
dark clothing, just off centre, to
give a human scale.
Pentax 6 x 7; 45mm lens;
polarizing filter; Fuji Velvia

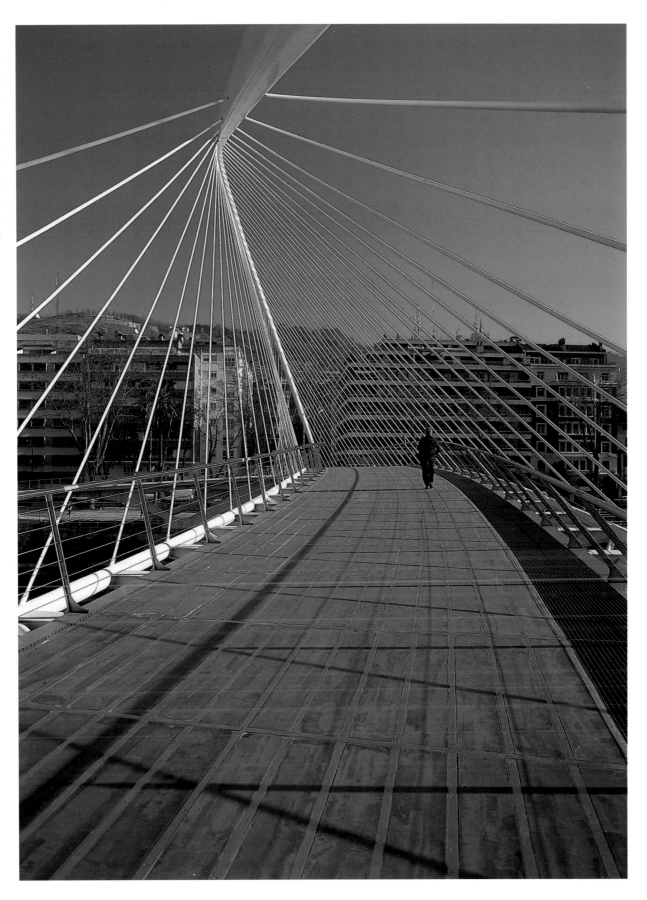

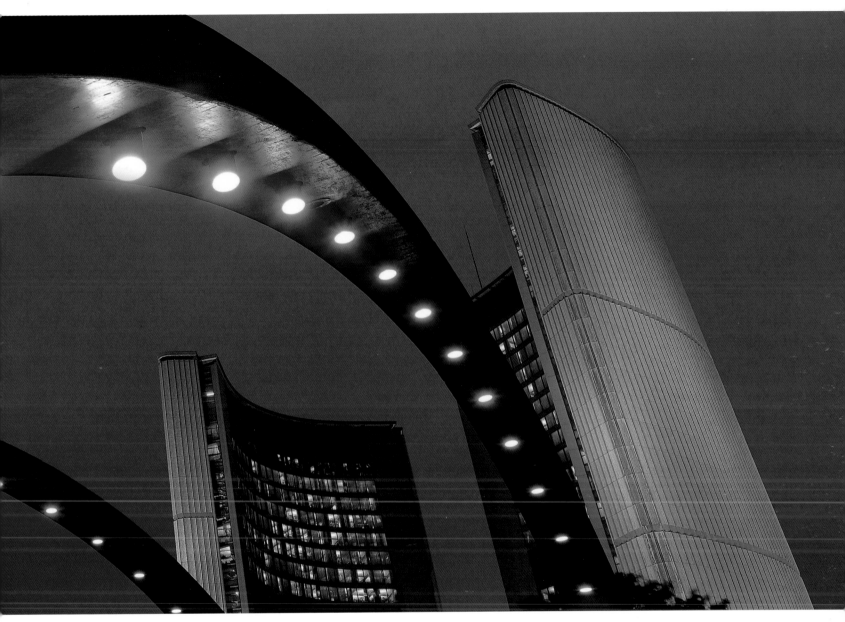

Toronto Civic Center, Canada

I shot this image during a short stay in Toronto on my way to Banff. Unfortunately, the weather conditions were not the best. With overcast skies and a threat of rain, I resorted to getting this night shot. The good thing about shooting at twilight is that it can disguise poor skies. I decided to use the panoramic format to give attention to the arches leading into the building.

Fuji GX617 panoramic; 90mm lens; Fuji Velvia

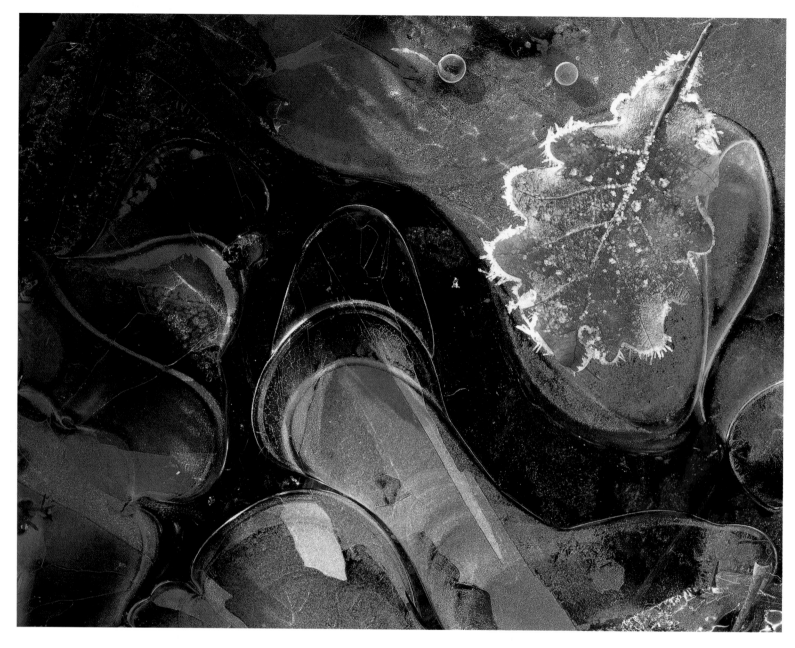

Ice design and oak leaf

I was attracted by the intricate shapes of the frozen ice. I didn't feel that they were strong enough on their own, so I carefully placed the frosted oak leaf in the upper right corner, angled slightly towards the ice shapes.

Wista Field 4 x 5; 210mm lens; Fuji Velvia

my 4 x 5 camera before the clouds moved away.) I used the Pentax 6 x 7 with a wide-angle lens to include the cirrus clouds.

Back in Bilbao, the shot of the footbridge (see page 25) was a more difficult one to achieve than the Guggenheim, because the bridge shook when people were on it. Although I was using a tripod, I had to wait until there was no one behind or in front of me, so I arrived very early in the morning. I needed a dark figure coming towards me and was lucky that someone came along at the right time. I love the pattern of lines and shadows on the walkway, but would have preferred to eliminate the ugly buildings in the background altogether. A polarizing filter both minimized them and accentuated the intense blue sky against the white cables.

THE NATURAL WORLD

In nature, the same principles hold true for finding compositions as for man-made structures. Look for distinctive shapes, lines, curves and patterns, and interesting details, as well as unusual colour and texture. Observing fine details of nature can unleash endless amounts of subject matter. It is important to know where to find good and accessible specimens of plants and trees and to visit them at different times of day and in different seasons. The early morning is always a good time to photograph plants, not just because of the directional light, but because the dew gives everything that extra dimension.

Be aware of how the weather can affect things: it can create some amazing and beautiful conditions. If it is below freezing, in particular, you might find intricate patterns created by the formation of ice, as I did here (opposite), or in a stream or waterfall you might find glassy shards of ice where the water has been dripping and gradually freezing, like stalactites in a cave. Frost can create some stunning textures on the surface of leaves and trees, providing them with a shimmering reflective layer.

You can create your own natural still-life compositions. In the photograph of the ice design (opposite), I deliberately placed the frosted oak leaf in the composition and I think its placement is crucial to the picture. I was careful

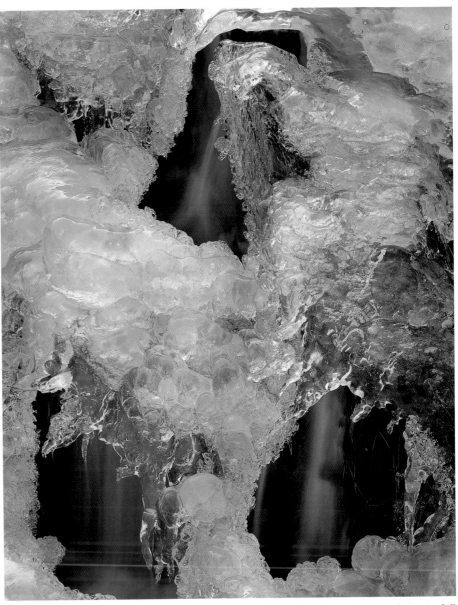

Three ice shapes in front of a waterfall
The abstract shapes in this partially frozen waterfall conjure pictures in the imagination. A ghost appears when it is viewed upside down.
Wista Field 4 x 5; 210mm lens; Fuji Velvia

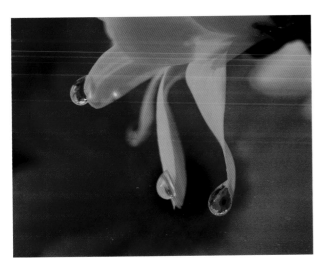

Dewdrops on flower
Coming in close to details of dewdrops on a flower reveals miniature lenses that encapsulate the images around the flowers. Careful positioning is needed to compose elements and ensure that critical focus is placed at the correct point.
Wista Field 4 x 5 with full bellows extension; 75mm lens; two +1 close-up filters; +4-stop adjustment for bellows extension; Fuji Velvia

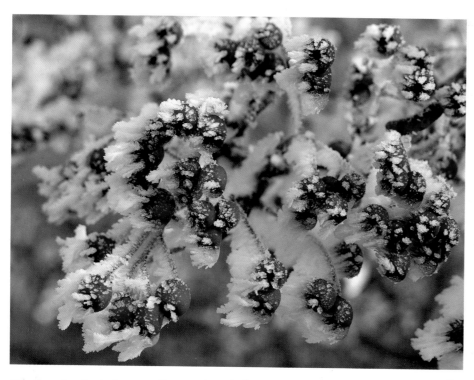

Hawthorn berries in frost

I was intrigued by the frost crystals shooting from one side of the berries as though they were blasted by ferocious cold winds. This gives a subliminal feeling of action to an otherwise static subject.

Wista Field 4 x 5; 150mm lens; Fuji Velvia

not to disturb the dark and active diagonal line running across from top left to bottom right. The alternating diagonal of the oak leaf brings the eye into the centre.

Sometimes when you are looking hard, your mind will play tricks on you and you start to notice shapes and images within what you see, rather like seeing animals in the billowing shapes of clouds on a fine day. When photographing this partially frozen waterfall (see page 29) in the Lake District, I homed in on three holes in the ice shapes and discovered that, when turned upside down, the image looks like a skull or a ghost. I have found that ambiguity of this kind in a photograph can often help it to sell.

MOVE IN CLOSE

The celebrated war photographer Robert Capa once said that if your pictures aren't strong enough, you're not close enough. Shooting at close range can make both natural and artificial subjects startling by what is revealed. It not only excludes unwanted detail and concentrates exclusively on the subject, but it has the further effect of intensifying colour and form.

Again, it is a question of viewpoint making all the difference. Photographers have a tendency to make images from their own working height, and by and large to the scale at which they are used to seeing things. So it is a simple thing to try a variety of angles of view and study things more closely than you would ever see them in passing. A snowflake is a well-known but excellent illustration of this: it is possible to see the extraordinary and delicate pattern of a snowflake by looking closely at it with the naked eye – just about. With your camera, you can make such small detail the subject of your picture and instantly allow viewers to study the passing intricacies of a snowflake at length.

Similarly, you only have to get down on your stomach and explore the world from an insect's point of view to gain an entirely new perspective on your surroundings. You will find that textures and arrangements of things that you had not previously noticed become important and interesting in the ground-level world.

In the shot of hawthorn berries (left), for example, coming in really close allowed me to show the ice crystals and the manner in which they had been built up on the berries. Such a close focus restricts the colour palette to the red of the berries and the sugary white of the frost. I found the three perfectly spaced spiders' webs (opposite) in the hedge of my own garden, which just goes to show that you don't need to go to the ends of the earth to get good, striking pictures. The important thing is to pay attention to the detail around you; try to see what many others ignore and you can come up with some astonishing images.

SHOOT THE SKY

It is easy to overlook the sky when visualizing a scene, even though it may make up a substantial part of the picture area. If you are photographing a striking sunset,

Spider webs in frost

I spotted these webs as I was loading up my gear to go out for an early-morning photo shoot. I liked the spacing of the three webs along with the natural diagonal lines and the subtle hint of colour.

Wista Field 4 x 5; 150mm lens; Fuji Velvia

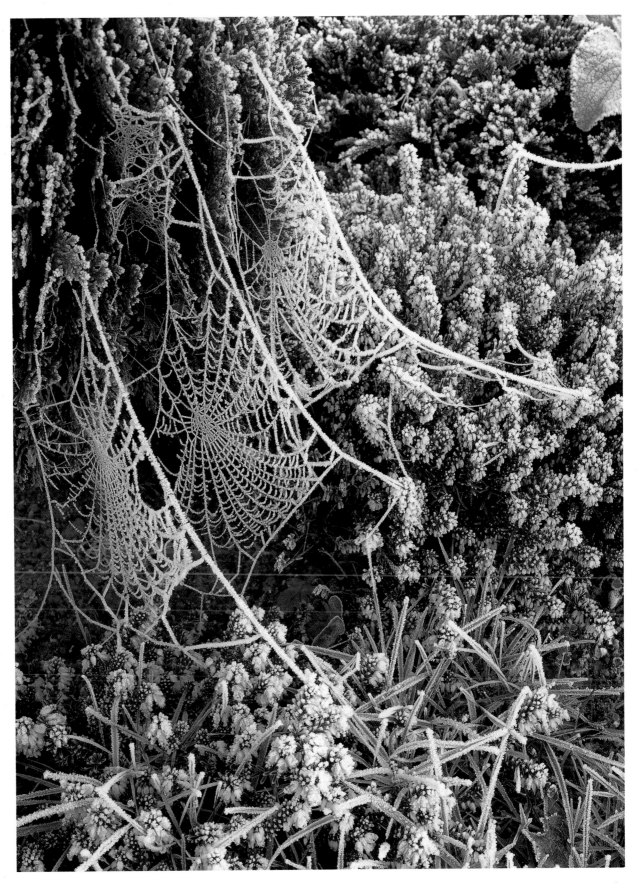

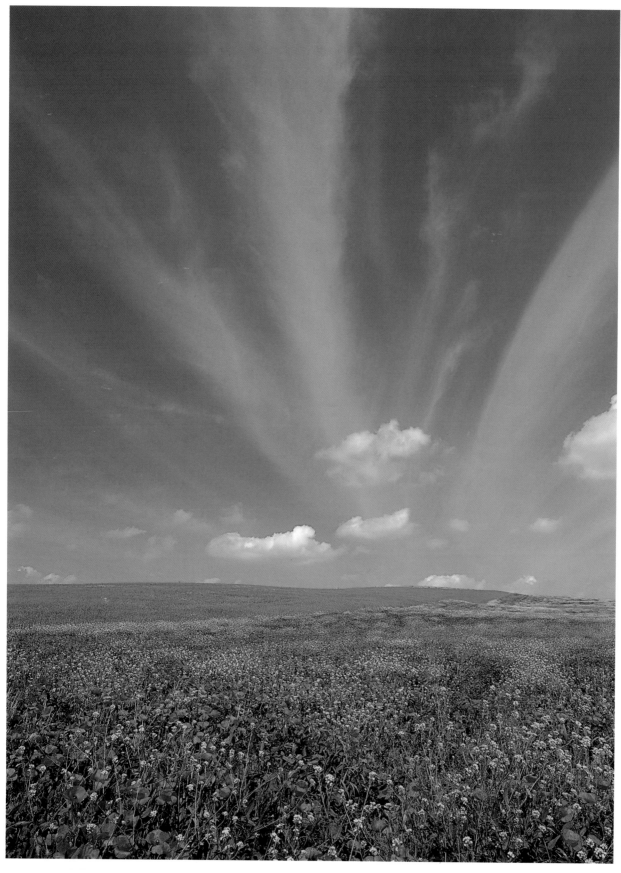

Field of wild flowers, Tuscany, Italy

When I saw this field of wild flowers, my first inclination was to photograph the flowers, but, as I looked, the shape of the clouds took precedence as they seemed to be radiating from the field. I quickly made several exposures emphasizing the clouds with a polarizing filter. Within minutes the clouds had moved and changed shape and the image was gone.

Pentax 6 x 7; 45mm lens; polarizing filter; Fuji Velvia

the sky is usually the main point of interest, but unusual skies can be equally useful in other shots. It is surprising how often I find that the the sky can be an important part of my compositions, the clouds falling in such a way that I can arrange my viewpoint to make them accentuate, or even provide the line of the composition. And, of course, the type of cloud can make a tremendous difference to the atmosphere of a photograph, whether it is brooding storm clouds or high, white and wispy summer clouds. By varying the amount of sky you include in the picture you can affect the atmosphere created from a feeling of tightness and restriction, where the sky is barely visible, to one of expansiveness and freedom (or perhaps loneliness), with a huge, wide sky.

I find that skies are best photographed at sunrise or sunset, or in a storm when there is a lot of turbulence, because in these situations dramatic shapes and colours are created. No weather conditions are unsuitable and often the most uncomfortable – rain and snow for example – produce some of the most powerful work. However, skies can be powerful elements at any time of day and in any weather, so you should certainly look out for how they may help your compositions. For more on atmospheric weather conditions, see pages 56–7.

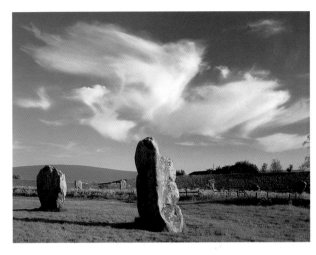

Standing stones, Avebury, Wiltshire, England

The cloud formations on this particular day were incredible. I wanted to make use of them within a composition instead of on their own. I was near Avebury and thought that the standing stones would make a suitable subject. After walking around the area, I chose this angle with strong side lighting and the clouds over the main stone.
Wista Field 4 x 5; 150mm lens; polarizing filter; Fuji Velvia

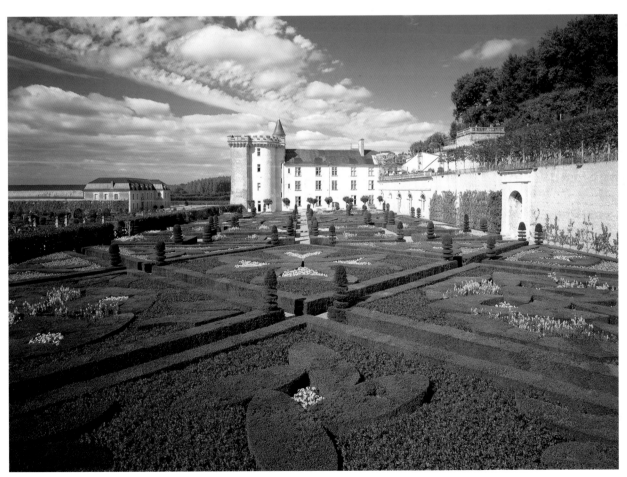

Chateau Villandry, Loire Valley, France

The strong lines of the garden leading up to the chateau are complemented by the clouds, which also act to draw the viewer's eye to the building.
Wista Field 4 x 5; 90mm lens; polarizing filter; Fuji Velvia

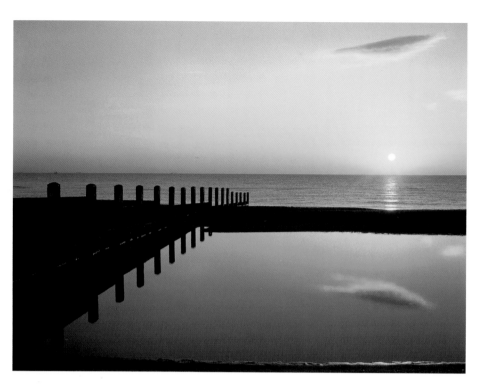

Horsey Gap beach, Norfolk, England
I was concentrating on the strong shapes of the groyne at sunrise. Just as the sun broke the horizon, a single cloud appeared above the sun and reflected in the tidepool. Without the cloud, the composition would not have been as strong.
Wista Field 4 x 5; 90mm lens; 0.9 neutral-density graduated filter; Fuji Velvia

BE READY AND GET LUCKY

Although I try to do everything in my power to control how my images come about, sometimes it is simply a lucky break that makes all the difference. In fact, a few of my favourite images (like this moon over the Apache National Forest, right) are those where some happy accident has provided me with a photograph that I wasn't expecting. All the elements just came together at the right time to create an image that couldn't have been pre-planned, and I didn't have to spend hours in the field looking for that perfect composition.

But it is possible to anticipate such fortuitous moments, or at least be prepared to make the most of them when they happen. In the case of photography, the more prepared you are, the more likely you are to get lucky. As well as going out on a shoot with my usual kit of cameras, lenses, tripod and so on (see pages 138–41), I plan very carefully where I am going to go to take photographs. I use detailed local maps showing contours and heights; these can give you ideas for vantage points from where to shoot, you can establish where the footpaths are that will allow access to good viewpoints, and you can plot where the sun will be in relation to your subject (for more on anticipating the light, see pages 52–5). If you are reliant on a fine day to get the shot you want, take a good look at the map in advance and you can find a back-up subject, such as a waterfall or woodland, should it be overcast.

Equally, moon tables giving dates and phases of the moon might come in useful. If

you are photographing seascapes, tide tables will give you high and low tide times, which could be crucial to the success of a day's work as, if you don't know the movement of the tide, and are unfamiliar with the particular shoreline, you can either find yourself being chased up the beach or literally left high and dry with the water miles out and not due back for several hours.

As much as you prepare and do research for a shot, there are often things that occur unexpectedly, either to your advantage or disadvantage. Be ready to seize the moment when it works in your favour. When I started shooting Horsey Gap beach (opposite) there were no clouds at all in the sky. Suddenly a single cloud came out of nowhere, but it absolutely made the shot as its placement is perfect – it would not have worked on the left of the picture as its reflection would have been lost and the relationship with the sunlight would have changed. In the end you can't control everything, but you can be ready to act quickly when the unforeseen happens.

Apache National Forest and moon, Arizona, USA
I was driving through this forest when I glanced out of the window and saw the moon in the dip of the tree line. The natural shape reminded me of the Chinese Yin Yang symbol. If I had been earlier the moon would have been too high and the sky too light, any later and the moon would have gone behind the ridge.
Pentax 6 x 7; 200mm lens; Fuji Velvia

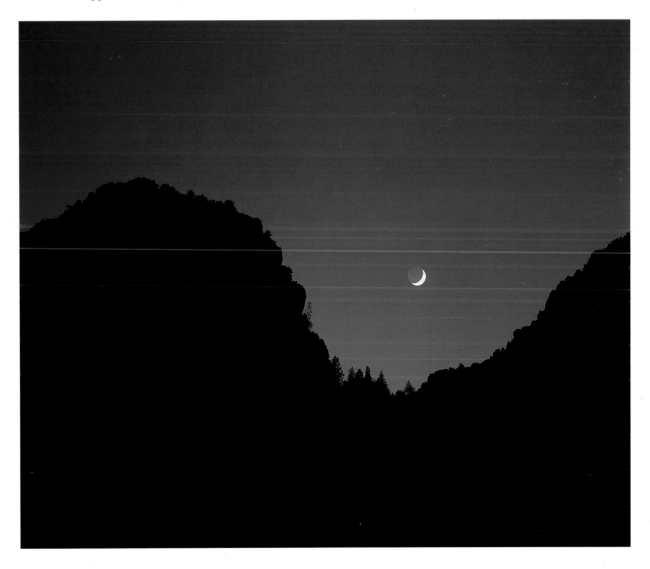

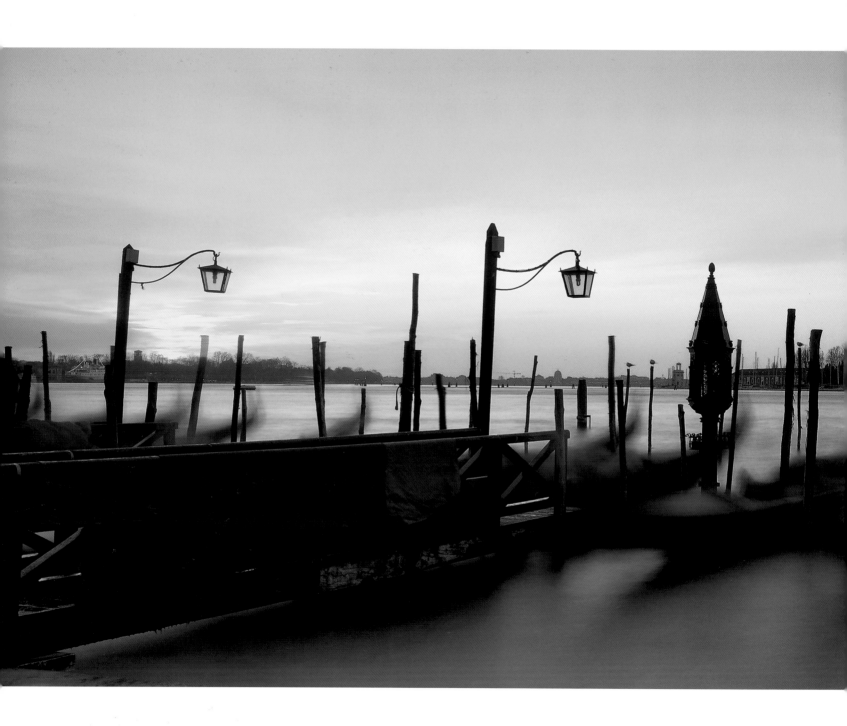

light

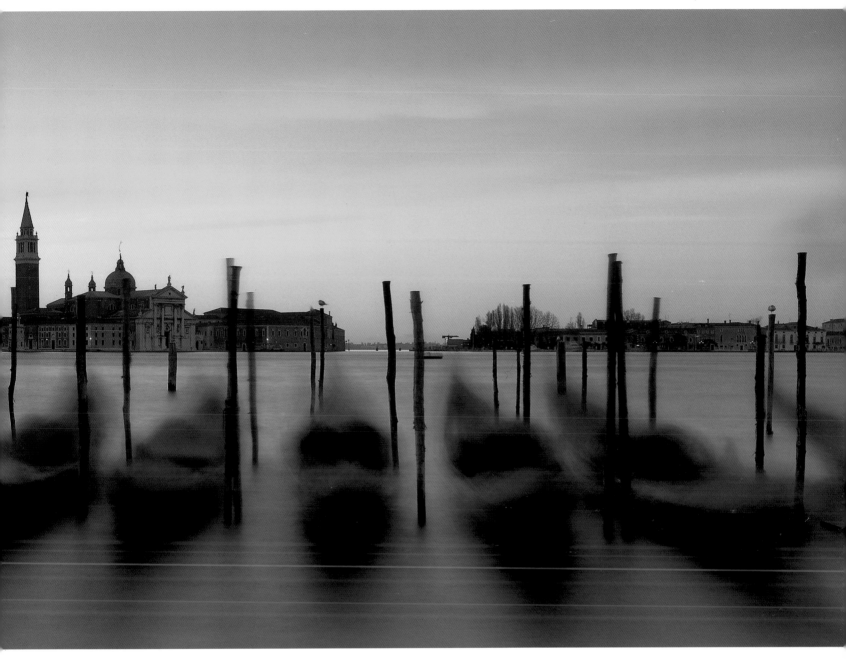

Gondolas at sunrise, Venice, Italy

This classic view of gondolas looking across to San Giorgio
Maggiore is ideal to photograph at sunrise as it faces southeast. A
long exposure was given to blur the gondolas to dream-like effect.
Fuji GX617 panoramic; 90mm lens; 0.9 neutral-density graduated
filter; Fuji Velvia

light is the most important aspect of any photograph as it defines the way we perceive the subject. The word photography literally means 'drawing with light', and it is really light and the way it behaves when it falls on objects that is our true subject. Natural light comes from a single source: the sun; but the sun manages to provide a near-infinite range of special effects. There are so many variables in the angle of the sun at different times of day, different times of year and at different latitudes, and just as much scope in changing weather conditions. Add to that the fact that these elements alter, minute by minute, throughout the day and have a corresponding effect on textures, colours and shapes, and you will see what tremendous possibilities there are in capturing different lighting effects.

CONTROLLING LIGHT

No matter how satisfying a composition, if the light is not controlled to achieve the desired effect, the final result will be disappointing. Diffused or reflected light is softer and gentler than direct sunlight, with a quality that releases the natural colours of a scene. Overcast days with contrast at its lowest reveal a wide range of shape, tone and colour, and you will be able to capture shadow detail much more easily. This is the time to shoot if subtle effects or delicate tones are required. At other times you need to intervene to influence how the light falls.

When I came across a perfect specimen of a fly agaric toadstool (left) while walking in woods in Norfolk, the light was too harsh, coming from one side and creating strong shadows. To retain the delicate details on the surface of the toadstool, and release the natural colour, it needed diffused or reflected light. I set up my 4 x 5 field camera on a tripod and composed the shot, rather like a studio still life, but instead of having the control of setting up lights or using a flash, I decided to influence the natural sunlight. To soften it I placed a diffuser between the sun and the subject, which cut down the contrast, revealing the saturated red of the cap and the yellow of the birch leaves scattered around the base. I used a collapsible round diffuser, but tracing paper or translucent plastic would

Fly agaric toadstool
Here I used a diffuser and reflector to soften the existing harsh light. Without this control, the detail in the shadows would have disappeared and the overall image would have been too contrasty. Wista Field 4 x 5; 210mm lens; diffuser and reflector; Fuji Velvia

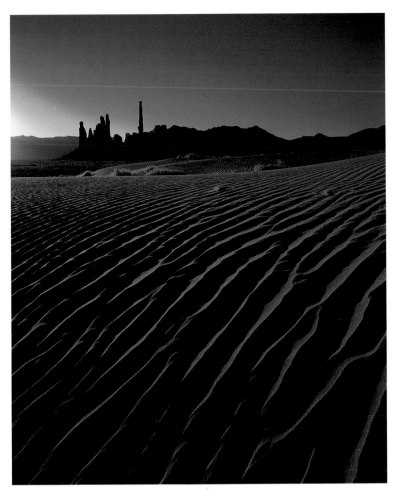

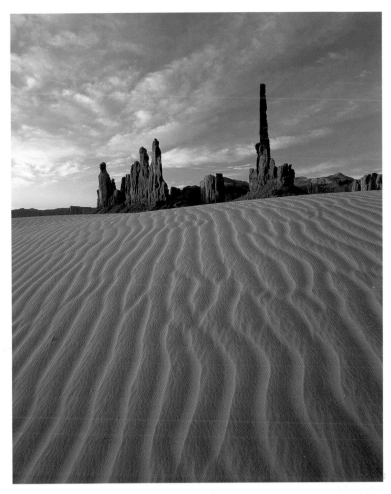

Monument Valley, Arizona, USA

Visiting the same location at different times of the year can produce entirely different results because of the changing latitude of the sun at sunrise or sunset. The first image (above, left), taken in October, shows the sun almost coming into the frame on the left. The second image (above, right) was taken in June, when the sun rises farther around to create a good side light.

Pentax 6 x 7; 45mm lens; polarizing filter; Fuji Velvia

Sossusvlei, Namibia

Strong side lighting brings out the texture and colour of the sand ripples and tumbleweed in the Namib Desert. Photographing just before the sun dipped below the horizon highlighted the long shadows, particularly the unusual one cast by the tumbleweed.

Pentax 6 x 7; 45mm lens; polarizing filter; Fuji Velvia

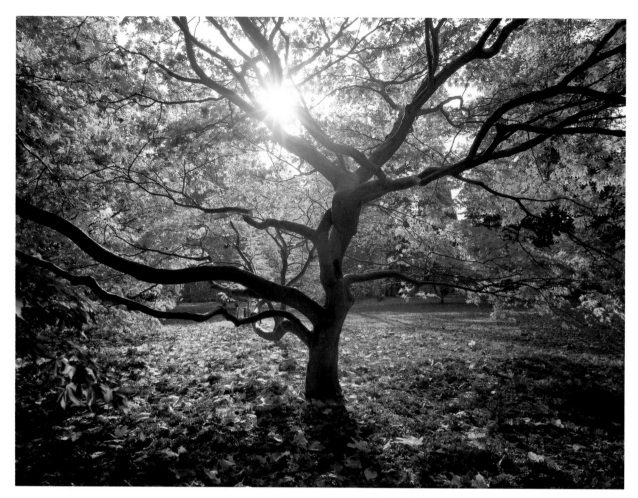

Maple tree, Westonbirt Arboretum, Gloucestershire, England
The back lighting of this tree brings out the brilliant colour of the translucent leaves. I had to be careful not to have too much of the sun peeking through the branches as that would have caused lens flare.
Wista Field 4 x 5; 75mm lens; Fuji Velvia

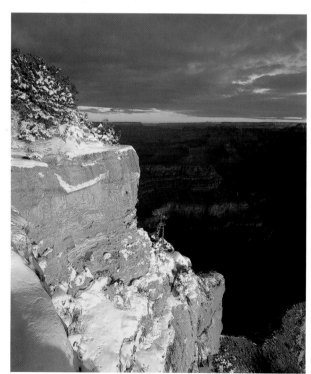

Grand Canyon, Arizona, USA
This image of sunrise at Yavapai Point illustrates how front lighting can produce deeply saturated colours when the sun is at the horizon. Within minutes the intense golden hue diminished and the light flattened out details in the rock face.
Pentax 6 x 7; 45mm lens; Fuji Velvia

have worked equally well. The shadow side was still too dark, so I used the dull side of a piece of foil to bounce light back into the shadows. Controlling the scene using diffused and reflected light brought out the natural colour and form of the subject. Such a method is not going to be possible outside for larger subjects, but it is a good illustration of how you can achieve more detail with softer light.

DIRECTION OF LIGHT

Front lighting (with the sun hitting your subject from the front) is the most revealing of details and provides good colour saturation, but it also flattens and reduces the three-dimensional qualities of forms. It can be dramatic when the sun is close to the horizon at dawn or sunset,

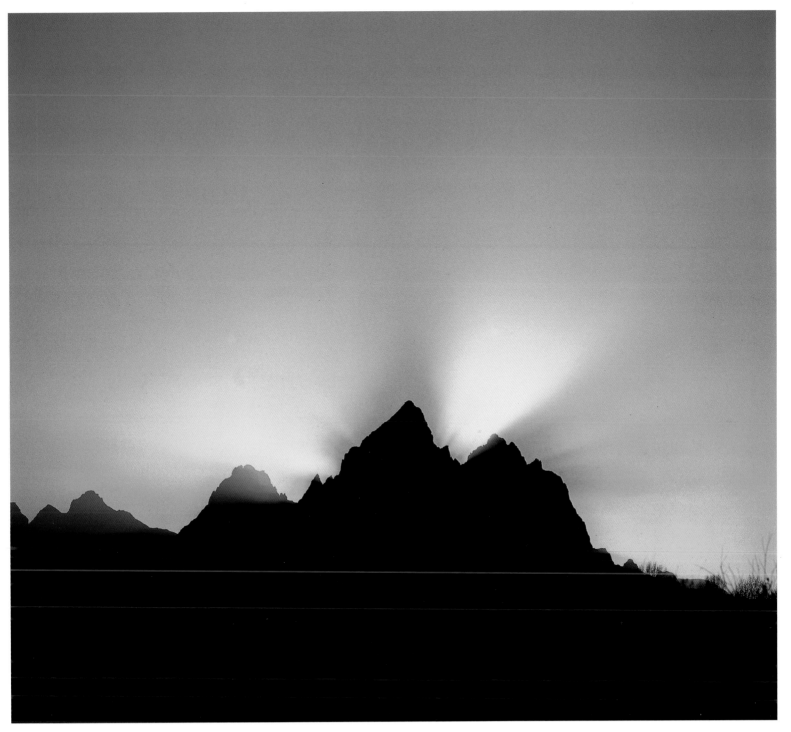

Grand Tetons, Wyoming, USA
Choose subjects with a clearly definable silhouette when using back lighting. Shapes can otherwise merge together, making it difficult to distinguish exactly what the subject is. The peaks of the Grand Tetons have a strong shape that is enhanced by the sun's rays streaming from behind.
Hasselblad 500C/M; 250mm lens; Fuji 50D

Welcombe Mouth, Devon, England

I wanted to show the impact of these waves crashing against the rocks. The sky was fairly overcast, but with a small break in the clouds at the horizon. As the sun peeked out, it lit the waves from the side and slightly to the back, giving a nice, warm glow to the water. I used a shutter speed of ¼ sec. This was slow enough to get some movement, but fast enough to freeze the waves.
Wista Field 4 x 5; 150mm lens; Fuji 50D

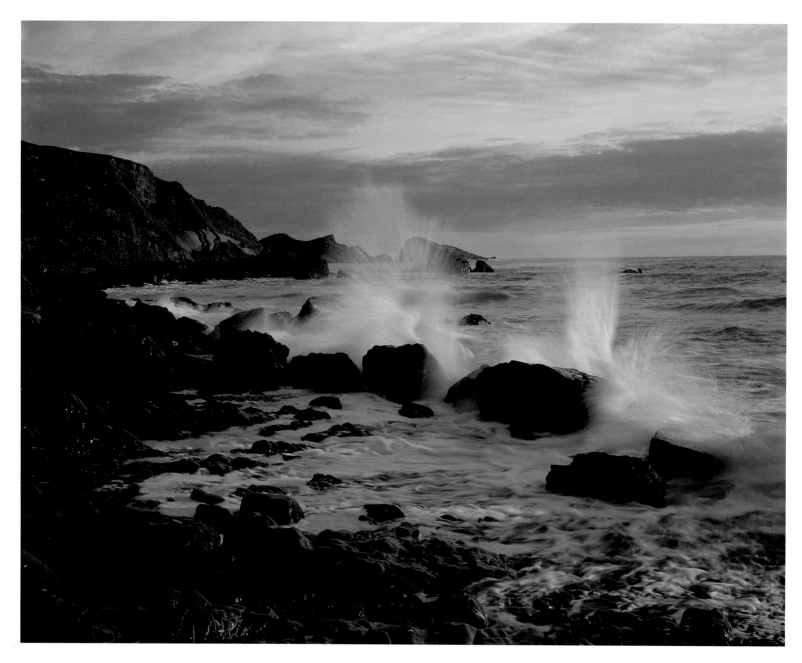

Cypress trees and field of wild flowers, Tuscany, Italy

The difference in the lighting in both images here has produced a totally different feel. The first image (right, above) was photographed under overcast conditions, creating soft, diffused light. The colours of the flowers are more saturated and more delicate detail can be seen. The second image (right, below) was taken under direct sunlight, producing more contrast.

Pentax 6 x 7; 45mm lens; 0.9 neutral-density graduated filter (right, above), polarizing filter (right, below); Fuji Velvia

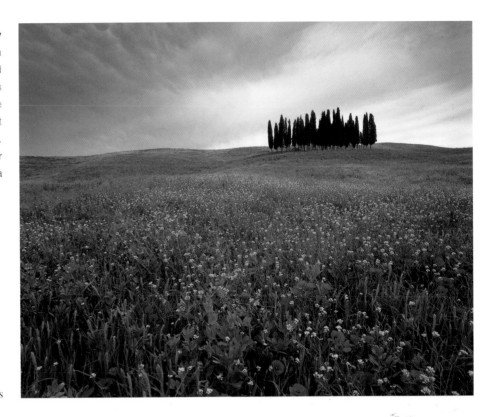

producing deep colour. As the sun rises higher during the day, the warm colour of the light fades and the forms flatten.

Back lighting is ideal for emphasizing shape; use it for spectacular silhouettes, creating 'rim' lighting around the edges of forms and for emphasizing translucency in subjects such as leaves, rain or flowers. Back lighting tends to subdue colour and throws the outlines of forms into stark relief against the bright background, which can be useful for unifying elements in a complex picture. It can also exaggerate depth by casting elongated shadows that emphasize the form and mass of objects. You're looking right at the sun, though, so you can try to hide the sun behind your subject if it is too strong, as I did with the maple tree on page 40, or you will need to shield the lens to avoid flare. Normally this is done with a lens hood, but I find these bulky to carry, cumbersome and time-consuming to mount, so often just shield the lens with my hand.

Side lighting is my particular favourite because of its capacity to emphasize contours, textures and forms. I often try to place myself in relation to the subject so that it is lit from the side. This obliqueness of light also creates a stronger contrast between the paler and darker surfaces in a subject and so brings out much greater definition of form. Early in the morning or late in the evening, when the sun is low, shadows are obviously longer, and with

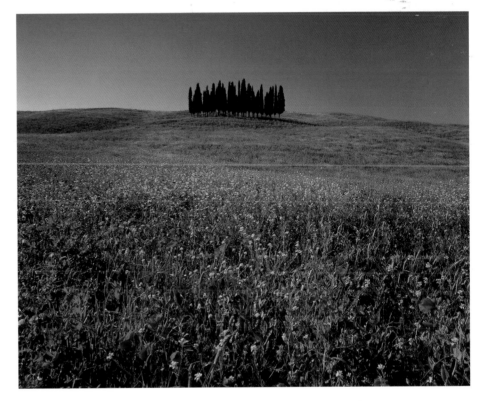

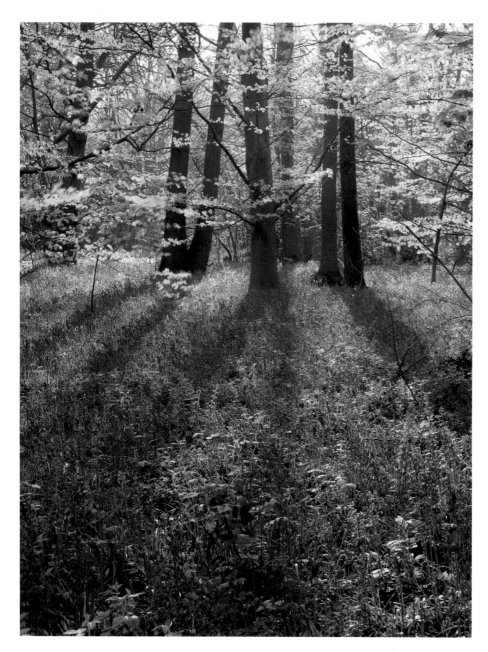

Bluebell wood, Norfolk, England
Strong, dappled back lighting streaming through the leaves created a stark contrast of light and shadow across the bluebells that gives this image an extra dimension.
Wista Field 4 x 5; 90mm lens; Fuji Velvia

this low angle of light, the smallest undulations in the landscape, invisible for most of the day, are revealed.

One type of directional light that photographers often avoid is top light. It tends to flatten form, especially in high summer, by pooling the shadows directly underneath the subject. The general effect is harsh and this is at its most extreme at noon on clear sunny days (especially at altitudes and near the equator). Top lighting makes intense colours appear stronger, and bleaches out paler tones. But because it gives boldness to forms, with bright highlights and small, sharp, black shadows, I have found it can give good results when I am photographing architecture. The image on the front cover of this book

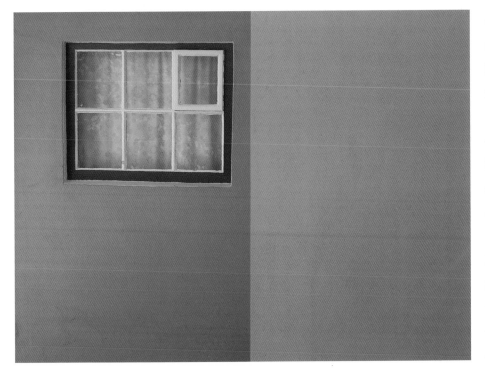

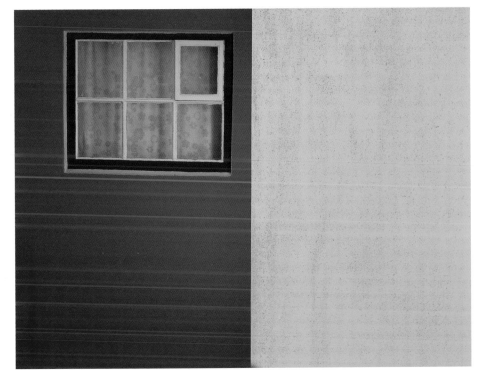

Window and wall, Swakopmund, Namibia
This simple composition was in a courtyard of a guesthouse where I stayed while in Africa. I photographed the first image (top) under soft, reflected light from an adjacent wall. The colours seem to glow with saturation. In the second image (above), harsh side lighting resulted in higher contrast and less colour rendition.
Pentax 6 x 7; 135mm lens; Fuji Velvia

was taken near midday, for example. In fact, buildings can often only be photographed in direct overhead light because of shadows from adjacent structures falling across them early in the morning or later in the day.

High tropical sunlight, however, is one of the most difficult conditions to work with due to excess contrast between the washed-out highlights and impenetrable shadow. In this situation I try to wait and photograph in cloudy conditions instead.

INTENSITY

Sunlight can vary enormously in intensity. For example, on a bright, sunny day, the difference between the intensity of light outdoors and indoors is immense. The human eye is much better at dealing with such vastly differing intensities than camera film, which will struggle to record too great a range, either bleaching out the brightly lit areas completely, or plunging the shadows into total blackness. As with the photograph of the toadstool (see page 38), a softer diffused light will bring out detail and colour in both light and dark areas.

The opposite of this is high contrast, and this is visible in the two photographs shown on this page. Of course the two areas of wall are actually the 'same' colour, painted with the same pot of paint. The tremendous differences in the way they appear to the camera in the two examples are entirely produced by the intensity of the light. In the top picture the wall is lit principally by reflected, and therefore soft and diffused, light from the adjacent wall. The intense colour saturation is maximized and the difference in colour between the lighter and darker areas is minimized. When the light is very intense and directional, as in the bottom image, the colour saturation is dramatically reduced, producing much paler shades, and the contrast between the two areas of wall in light and shadow is extremely marked.

TIME OF DAY

Photographed at different times throughout the day, the same image will have quite different characteristics and moods. It can be an interesting experiment to make the same photograph at intervals in a day and, for that matter, to come back at different times of year to do the same thing, as the angle of the sun, its rising and setting points on the horizon and the atmospheric conditions will all be quite different, producing distinctive results.

Before sunrise, lighting is indirect and predominately blue and cold. After sunrise the light becomes yellower and less diffuse and the direct light will separate forms, revealing detail, texture and colour. At noon the light is nearest to being colourless, and saturation is reduced. In the afternoon, light is strong and blue and the contrast high. Lower and softer light in the late afternoon creates modelling of forms, revealing their detail and texture. As the sun begins to set, pinks, oranges or yellows can appear and rapidly change in the sky, and shadows are more intense. The low, diffused light will bring out maximum detail. As the sun drops below the horizon there are still some warm pinks and yellows in the sky, but the overall feel is bluer; shadows will be dark and silhouettes strong. After sunset, twilight offers unique and moody qualities, though the level of light is, of course, dim.

When I arrive at a location, whether it is a building, landscape, garden or cityscape, the first thing I do is survey the area to decide what time of day would best suit the subject. Invariably I find that I am there at the wrong time and need to wait until the light is right. Spending time in a location to understand how the light reacts with it at different times of day is never time wasted, though, and you can make an almost infinite variety of images in a day with the light coming from different directions and in different atmospheric conditions.

But I find the best time to shoot is almost always the couple of hours after dawn and before dusk when the sunlight is slanting low, giving a rather theatrical look to the land. It is at just these times, at each end of the day, when the light changes most rapidly, so you always need to work quite quickly. During these crucial periods, it's a

Tobagan sunset

I usually shoot a succession of images during a sunrise or sunset as the colour and atmosphere of the sky is changing by the minute. In the first image (below), the sun is just above the horizon; but a few minutes after the sun dipped below the horizon (bottom) was when the sky peaked with colour.

Pentax 6 x 7; 45mm lens; Fuji Velvia

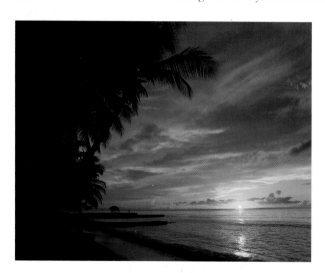

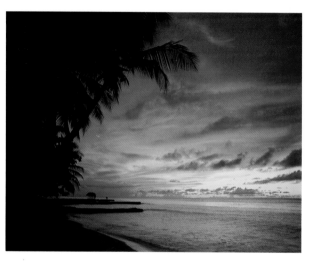

good idea to take a series of pictures at intervals of just a few minutes. You can be presented with many different moods in a short space of time and unless you are ready, you can prepare for one shot and be ready to go, only to find that the light has changed completely and you need to set up again for the new conditions. For this reason I rarely use polaroids when I am working in the field; I find that by the time I have decided what I am going to do, taken a polaroid, waited the minute or so for it to develop and checked that the shot is working, I may have missed the moment. I would rather take a risk and get the image on film rather than go home with only a perfect polaroid to show for it.

POOR LIGHT

When travelling, I have often come across a scene where every aspect of the composition is perfect except for the light. Dull, overcast light does not bring out the contours and colours of some scenes to their best advantage. What I tend to do if I feel conditions are

Pigeon Point, Tobago

I went past this scene just about every day at various times. The morning sunlight (top) creates a totally different feeling from the light at dusk (above). Spending time with your subject will broaden your perception of light.

Fuji GX617 panoramic; 90mm lens; Fuji Velvia

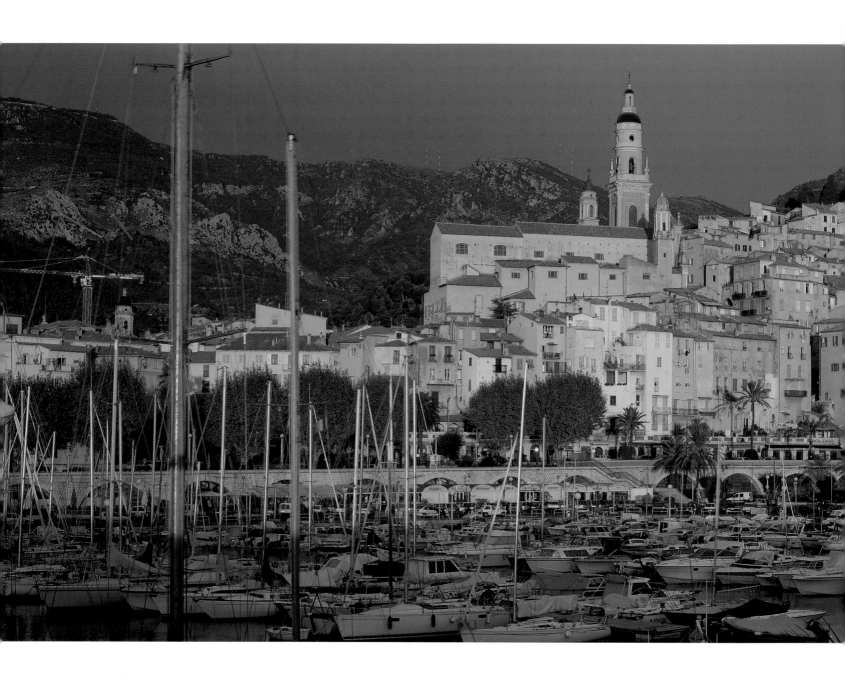

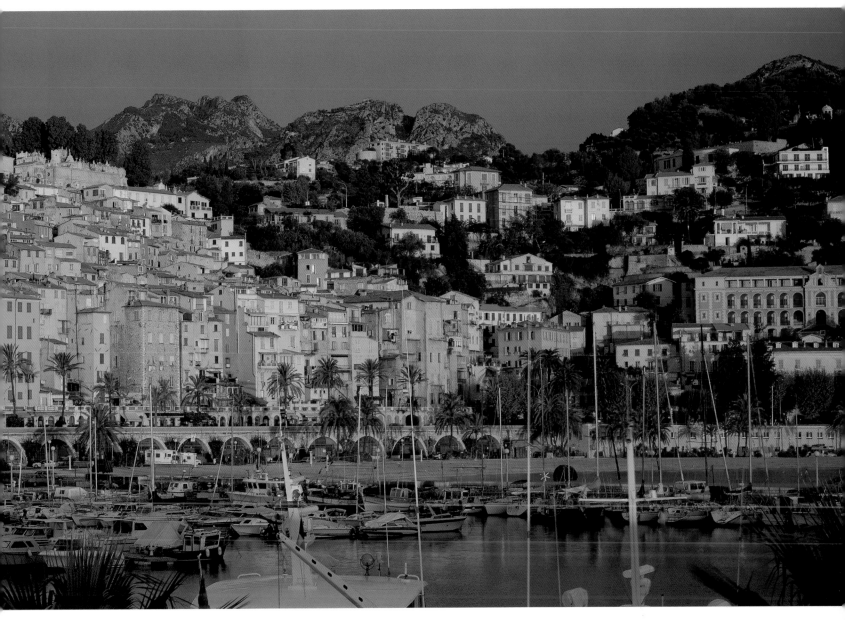

Menton, France

The harbour and hillside buildings of Menton are a fascinating location to photograph. I arrived here late afternoon and, as the town faces south, I felt that warm light at sunrise would emphasize the Mediterranean colours of the buildings. Next morning I set up and waited for the sun to rise. Unfortunately, a huge bank of clouds loomed over the southeastern sky, with a narrow break just above the horizon. Luckily, the break allowed about a minute of strong, direct light before the sun ascended into the clouds.

Fuji GX617 panoramic; 90mm lens; Fuji Velvia

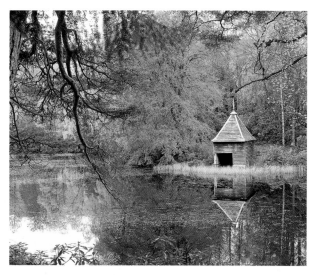

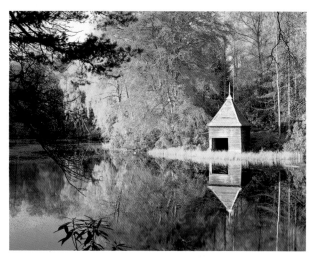

not right is to make a note of the location, direction of view and the type of light I think would suit it best, and aim to return to it another day.

Having said that, dark, threatening skies and rain need not bring picture making to an end – there are a number of subjects that perfectly suit it. I look for gardens, waterfalls and woodland subjects in particular, as these actually often give better results when photographed in more muted light conditions. An overcast sky takes the edge off any brightness, lowering the contrast between dark and light areas and giving very even exposure readings across the scene. For example, this white waterfall against black rocks (opposite) works in a way in which it would not in harsh light, where the detail among the rocks would be burnt out.

The best conditions in which to photograph gardens are under hazy, overcast skies as this gives an even, soft light and intensifies colours. The degree of brightness will affect how three-dimensional a subject appears. In the images of the loch (left), the hut appears two-dimensional in the strong-bright light, and has more substance in muted light. I try to avoid including a washed-out, grey sky in such shots as it has a tendency to distract the eye from the well-modelled subject and on to the gloomy weather. But, if an over-cast sky has texture and detail, it can add to the atmosphere.

You can also produce excellent pictures in the rain – especially of waterfalls. Not only is the water flow increased in the wet, but the vegetation around it glistens, making the whole scene lusher and greener (see also page 127). What would be really useful in a

Loch Dunmore, Pitlochry, Scotland
Even on dull, overcast days I continue to photograph in forest and woodlands. This quality of light gives pastel, muted colours as in the first image (top). The next day I photographed the same scene under direct sunlight (above) and the image produced vibrant colours for a different effect. Even under overcast conditions I used a polarizing filter to remove reflections of the foliage, revealing the true, saturated colour.
Wista Field 4 x 5; 150mm lens; polarizing filter; Fuji Velvia

Topiary tree, Levens Hall, Cumbria, England
The details under this tree would have been cast in shadow under bright sunlight. When photographed in dull, overcast light, the colours are saturated and detail is retained.
Wista Field 4 x 5; 90mm lens; polarizing filter; Fuji Velvia

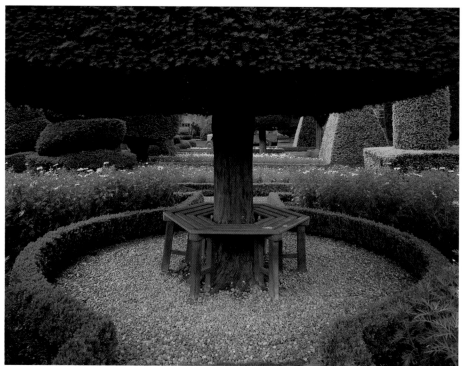

Golling waterfall, Austria
Waterfalls are perfect for photographing in bad light. I have even photographed them in the rain. The light is fairly even, though long exposures may be needed. Long exposures produce an ethereal, silky look to the water.
Wista Field 4 x 5; 90mm lens; polarizing filter; Fuji Velvia

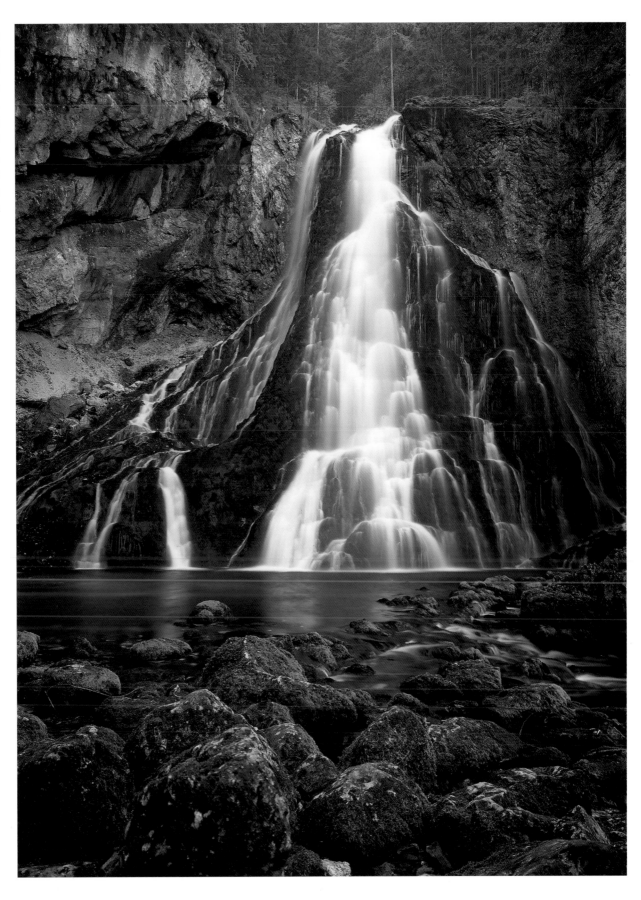

situation like this, especially when working alone, is a large telescopic umbrella that can be stuck into the ground so that both hands are free to take pictures.

ANTICIPATING THE LIGHT

An understanding of how the changing light and weather will affect the picture, and knowledge of how the weather patterns move – when clouds are likely to scatter or the sun break through – is a tremendous advantage in maximizing your chances of being able to get the photograph you want. Being able to pre-visualize an image is an important tool in dealing with whatever the light and weather throw at you. The term pre-visualization, in photography, is closely associated with the great American photographer Ansel Adams, and refers to being able to 'see' how you want the final print to look in the scene you are about to photograph. The way you choose to photograph the scene is determined by the pre-visualized image. In theory, experience and technical know-how will tell you, the moment the shutter is released, what you have committed to film. Ansel Adams would know at once when he had created something special. I feel exhilarated when I

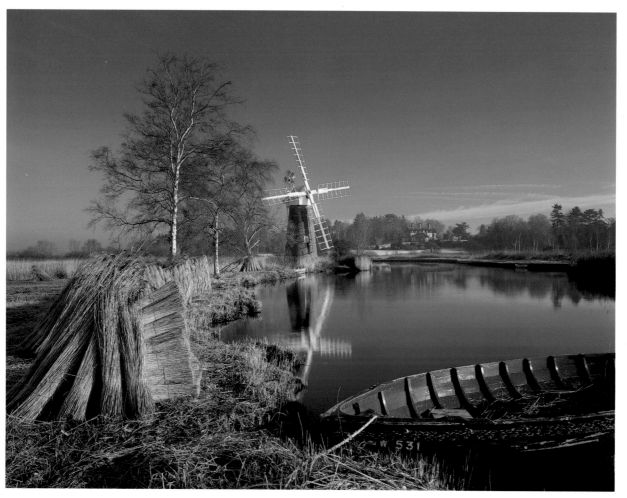

Turf Fen Mill, Norfolk, England

When I first moved to England, I started photographing the area around How Hill, and it remains one of my favourite locations in Norfolk. I had become good friends with the reed-cutter, Eric Edwards. I explained a shot that I had visualized containing a boat, reeds, and the mill in the background. Several years later, after many trips, the conditions and composition came together to form what I had visualized. Wista Field 4 x 5; 90mm lens; polarizing filter; Fuji Velvia

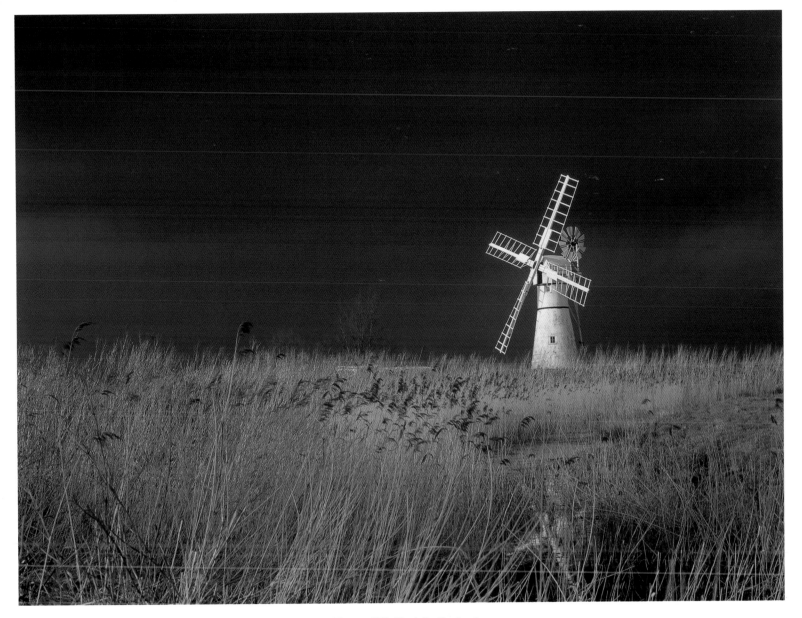

Thurne Mill, Norfolk, England

I went to photograph Thurne Mill on a cold, winter's day. The conditions didn't look too promising for getting any decent images. I spent a considerable amount of time huddled next to a tree to keep out of the sleet and snow, hoping for a break in the clouds. My patience paid off as I could see a hole appearing in the clouds to the west. I quickly set up the 4 x 5 on the tripod. The mill and reeds were lifeless without light. In my mind, the mill would be stark against an almost black sky and the reeds would glow with warmth. I quickly positioned a 0.9 neutral-density filter over the sky and a graduated coral filter from the bottom of the frame to warm the reeds. The hole in the clouds moved towards the sun and I managed to fire off two sheets before the sun disappeared for good.

Wista Field 4 x 5; 150mm lens; 0.9 neutral-density graduated filter, graduated coral filter; Fuji 50D

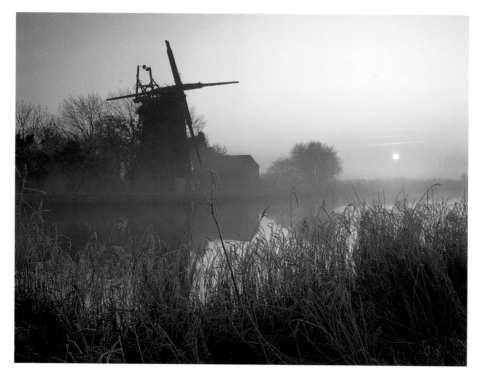

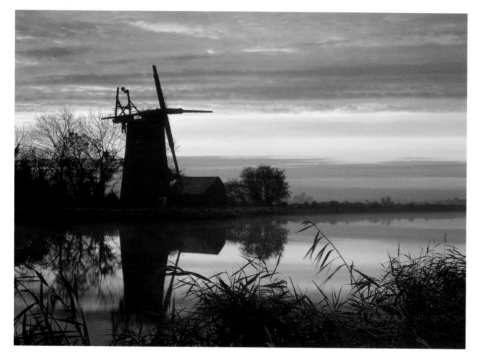

Oby Mill, Norfolk, England

I wanted to get a shot of a mill at sunrise with the morning sky reflecting in the river. Oby Mill was the best choice as it is one of the only mills positioned on the east side of a river. After several attempts, the conditions never quite gave me the result that I had visualized. The first image (top) was acceptable, but it didn't have the clouds to pick up the pre-sunrise colour that I wanted. After a few more early rises, I finally achieved the image I wanted (above), complete with clouds.
Wista Field 4 x 5; 150mm lens; Fuji Velvia

know I've made an image that is important to me, and this feeling is the motivation that keeps me going back into the field.

Being able to imagine what you want to achieve and forming a plan to achieve it is one thing, but there are so many variables and unknowns that may impede you. Preparation and research are important and can cut down on the element of chance. There is a lot you can find out about a location to give yourself the best chance of 'anticipating' the light. If you know that you want to photograph a particular scene, for example, (as I did the windmill, left), you can work out the angle of the sun and how it will hit your subject at various times of the day and year using a detailed relief map to decide where you should be in relation to the sun and your subject. I also have a table that charts the times of sunrise and sunset at any given time of the year. Using this I can determine when I need to be at a particular location so that the sun will be just right for my composition. In the case of the windmill this only got me so far: I still had to wait until the weather conditions at dawn gave me what I had originally visualized – clouds picking up the dawn light and reflected in the river.

Going back to the same place time after time gives me a better understanding of the individual location. I see it in different light and weather conditions so each experience, and image that I shoot, is unique. This has undoubtedly helped me on the business side of stock photography. Recently, a client saw a photograph of a manor house that I had shot in the autumn; they liked the image but really wanted something like it that had been photographed in the summer. Fortunately, as it was a classic view, I had been back and photographed it at different times of the year and was able to provide from my existing stock exactly the image they were looking for.

Teardrop Arch, Monument Valley, Arizona , USA

These two images show adverse effects of lighting when photographing a location at different times of the year. The first image (right) was taken in October. Because of the low angle of the sun at that time of the year, distracting shadows are cast across the arch from a mesa behind me. The second image (far right) was taken in June. With the sun higher and farther north in the sky, it clears the mesa and gives a nice sidelight that brings out the texture of the rock face.

Pentax 6 x 7; 200mm lens; polarizing filter; Fuji Velvia

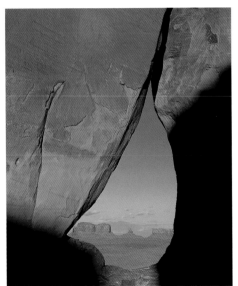
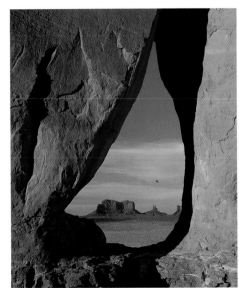

Another advantage of returning to the same location is that you can get to know the people who live and work there. However often you as a photographer go back to the same scene in different conditions, you are never going to be able to get to know it as intimately as those that spend time there every day. Talking to people who have a better insight into a location, its quieter places and lesser-known aspects, such as park rangers, guides and locals, can provide helpful information.

I have photographed around How Hill in Norfolk many times and have, for example, got to know the reed-cutter there quite well. Being able to talk to someone who is as close to the local landscape as he is has been invaluable to me, and he helped me to achieve the photograph on page 52 with the cut reeds in the foreground and the windmill in crisp wintry morning light against a clear sky.

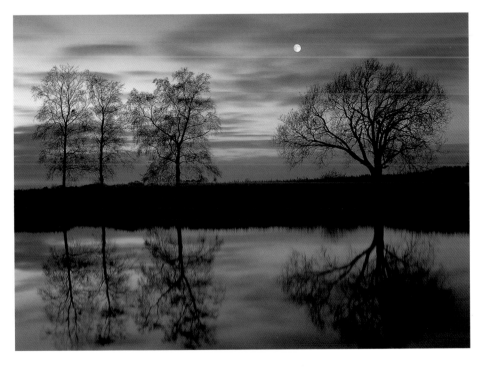

Moon over River Ant, Norfolk, England

There are times when the visualized image is not possible because of the constraints of nature. In this case, the full moon was slightly out of frame, so I double-exposed the moon into the composition where I wanted it. This is actually technically better because if the moon had been in the frame during the long exposure, it would have burned out. I slightly underexposed the moon to ensure the detail would be retained.

Wista Field 4 x 5; 150mm lens (main image), 210mm lens (moon); Fuji Velvia

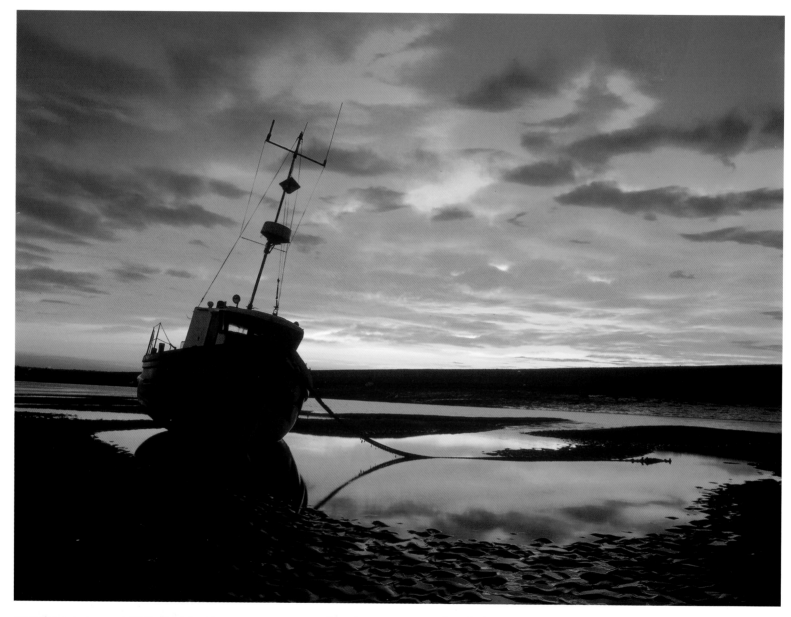

**Fishing boat at sunset, Wells-Next-the-Sea,
Norfolk, England**

Having a great sunset is not enough to make a dramatic image.
Including a strong silhouette and foreground is equally important.
For this image, when the clouds started turning yellow, I quickly
walked out over the mudflats to use the boat as a silhouette against
the sky. The tidepool in the foreground was essential to separate
the dark elements by reflecting the sky. As the sunset progressed,
the sky became aglow with deep crimson. The peak colour lasted
only a few minutes.

Wista Field 4 x 5; 90mm lens; Fuji Velvia

It took me many trips there before the weather conditions were just right, but it would
have taken me many more had I not learnt from Eric just when and how the reeds
would be cut.

ATMOSPHERE

Atmospheric lighting is the element of magic in a photograph that makes all the
difference. Images with atmosphere can make us feel calm, or excited, or in awe. They
have real impact upon us. The trouble is that, while it's easy to know when lighting
conditions are atmospheric, it's very hard to anticipate when this magical quality is going
to occur. Often it will be when you least expect it or when you've left your camera at
home. How many times has the sky become awash with a brilliant crimson colour or an

intense rainbow appeared in just the right setting and you've been caught without your camera? Apart from taking your camera with you whereever you go, I believe you really have to go looking for atmosphere and take the calculated risk of putting yourself in the right place at the right time.

I have found the best places to look are where there is a change in conditions, on the edge of a clearing storm, the crossover between day and night, the days when the seasons are changing – the last days of autumn and the first of winter, or the first signs of spring – or on the edge of a low- or high-pressure weather system. It is at these times that tension is created, things collide, and although it may be unpredictable, there is a better chance that something spectacular will happen. This could be a dark and brooding storm, full of menace and foreboding, charging the atmosphere with its imminent violence, or the precious final minutes of sunset when the day and the night are in perfect balance and the darkening landscape is illuminated by a magical light show. Put yourself on the edge rather than being a fair-weather photographer.

Being able to recognize how weather conditions are likely to develop is a great asset for capturing dramatic pictures. Sunsets like the one pictured opposite need a certain amount of forward planning – if you are standing admiring the colours, then decide to fetch the camera, find an angle, set up the camera on the tripod, and compose the image, it's likely to be much too late when you come to press the shutter, and the colours will have long-since faded.

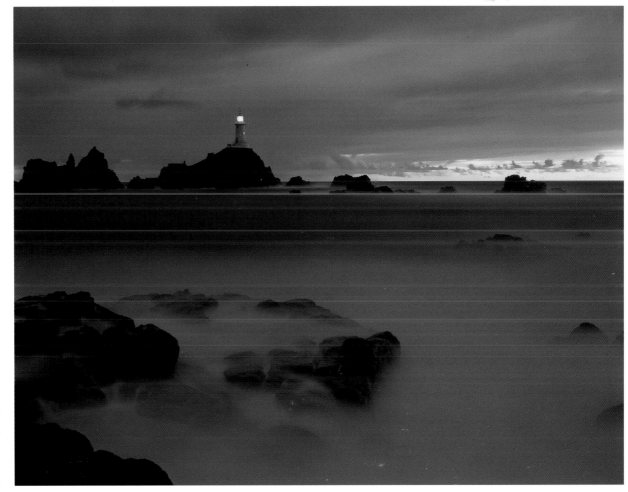

**Corbière lighthouse,
Jersey, Channel Islands**
I captured this lighthouse on the edge of a clearing storm. I used a long exposure to take in several passes of the searchlight and allow the crashing waves to transform into an ethereal mist effect.
Wista Field 4 x 5; 150mm lens;
Fuji Velvia

Heliconia, Tobago

In order to make the brilliant red stand out even more with back lighting, I had my guide hold a dark cloth behind the flower. This also served to cover up any distracting foliage in the background. Vibrant colours such as red, orange or yellow always stand out even more when backlit and placed against a dark background.

Pentax 6 x 7; 135mm macro lens; Fuji Velvia

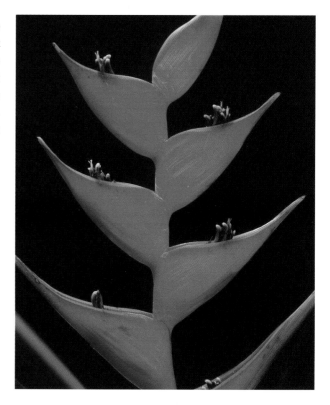

Camel thorn tree shadow, Deadvlei, Namibia

I had seen many photographs of the dead camel thorn trees in Namibia. The trees backed by the salmon-coloured dunes are impressive, but I wanted to create a different perspective. I felt the shadow of this tree provided a strong shape that complemented the trees and dunes in the background.

Pentax 6 x 7; 45mm lens; polarizing filter; Fuji Velvia

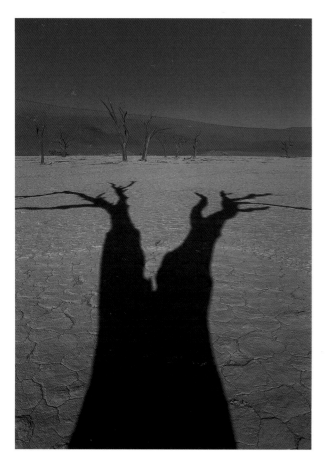

The signs to look for when setting up to photograph a sunset are modest cloud cover with a break on the horizon. In these conditions, the chances are very good that when the sun dips below the horizon it will illuminate the clouds, and produce a spectacular display of oranges, yellows and crimson-reds.

SHADOWS

Light creates shadows, and shadows play a crucial part in adding impact to a photograph. It is vital to be aware of where the shadows fall within an image and how they are affecting the composition. The interaction of light and shadow is primarily responsible for giving a subject shape and texture. Landscapes will appear flat and lifeless without this interplay — it is the shadows that bring out the contours of the land.

Deliberate placement of areas of shadow in your compositions is a very useful technique. An area of shadow can be used as a background to make the main subject stand out. Particularly warm colours such as red, yellow or orange will have greater visual impact when placed against a background that is thrown into shadow. If you place a dark shadow across the bottom of the frame, this can provide a strong base for the composition. Art directors of magazines and books love foreground shadows as a design element because they provide a dark area over which text can be printed. You can even make a shadow the main subject of an image as I did with this camel thorn tree in Namibia (left).

I've found that the shadow cast by interesting trees or an unusual sculpture can often make a more interesting photograph than the object itself as the changing angle of light will lengthen, shorten or distort the shape.

Particular attention needs to be taken when using high-contrast films such as Fuji Velvia, which is my first choice of film for most subjects. Velvia is well known for producing punchy, highly saturated images, but these attributes come at a cost – the loss of shadow detail derived from the rich black inherent in the film emulsion. The human eye is extremely sensitive to light, constantly adjusting so that we can see detail in the bright highlights and dark shadows around us. Transparency film, on the other hand, is capable of recording a range of only five stops, two stops over and under the optimum exposure. Much of the detail that we can see with our eyes disappears when recorded on transparency film. When I look through my viewfinder I squint my eyes so that the difference between the highlights and shadows is minimized. This way I can see what effect the shadows will have in the final image. Looking at the scene and briefly squinting your eyes to reduce the amount of light can achieve the same result. Pay attention to

how the shadows interplay with the composition, making certain that important details are not eliminated, confused or dominated by too many shadows. The detail in overlapping shadows, for example, might be readily distinguishable by the human eye, but transparency film can merge the shadows into one dark mass.

LIGHT REFLECTED

Reflections are one of my favourite subjects to photograph. Their creative possibilities are boundless. A slight breeze across the surface of water converts a flat plane into an impressionistic painting; the distorted shapes of reflected objects in mirrored buildings take on an abstract appearance. A perfect symmetrical mirror image in the still calm of early morning, can seem to be a visual trick, or the reflection alone can have a powerful visual impact.

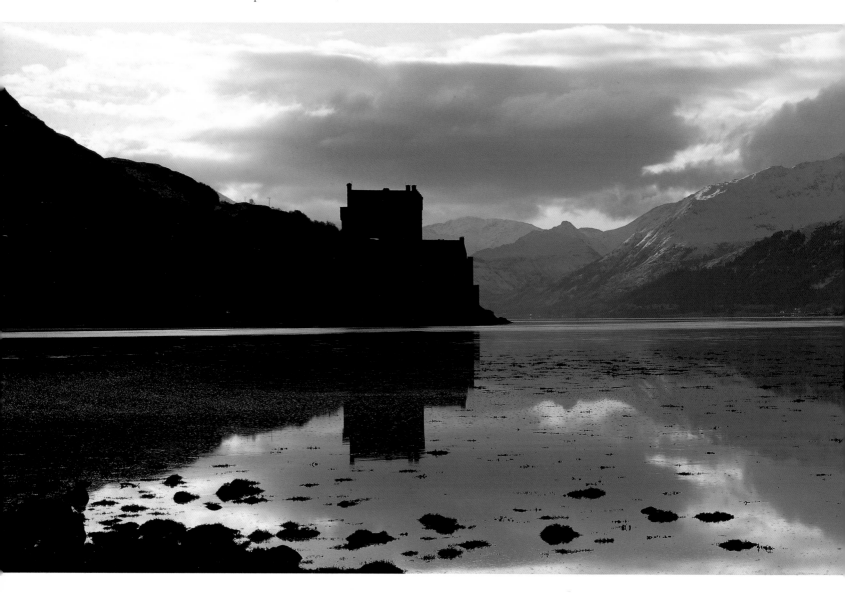

Loch Alsh reflections, Scotland

I captured the wintry sky and mountains reflecting in Loch Alsh early in the morning before the wind had a chance to pick up. The dark rocks in the foreground give an interesting base. Eilean Donan Castle is the most photographed castle in Britain. I wanted to make the reflections the main focal point and the castle a secondary subject in this image .

Fuji GX617 panoramic; 90mm lens; 0.6 neutral-density graduated filter; Fuji Velvia

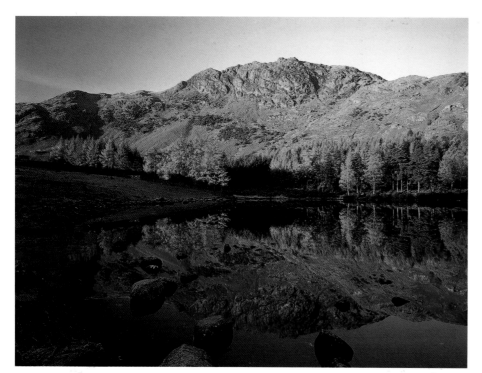

Blea Tarn, Cumbria, England

I've tried getting good reflection images at Blea Tarn on several occasions, but it was either too windy or the lighting conditions were poor. With a forecast for a frosty morning, my chances looked promising for good reflections.

Wista Field 4 x 5; 90mm lens; polarizing filter; Fuji Velvia

The best time to photograph reflections is in the morning when the air is more likely to be still. Often compositions using reflections will present themselves very obviously, while others need to be searched out. I've walked on beaches where many small tidepools reflected the sky, but when I changed my point of view and lay flat out on my stomach I could see a subject on the horizon bathed in the early morning light. I always keep a space blanket in my camera bag for situations like this. I can spread the blanket out and rest the camera and myself on it without getting covered in wet sand. Space blankets also make good impromptu reflectors.

Pay attention to the depth of field when photographing reflections. If the reflection is close to the lens at least part of it may easily be out of focus. Use a wide-angle lens and a small aperture to keep everything sharp. Often the subject itself can be as many as 2–4 stops brighter than the reflection. In order to record the brightest highlight of the subject and the darkest shadow of the reflection I spot meter off an area between the mid-tone and darkest area of the reflection, then meter off a mid-tone in the main

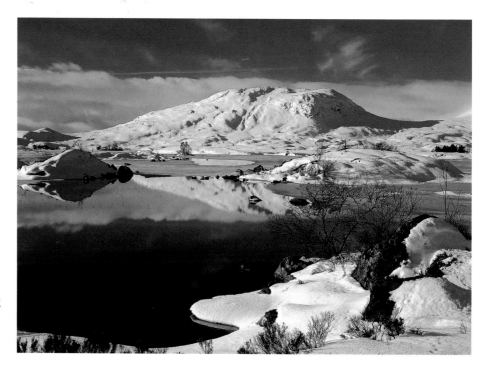

Black Mount, Scotland

Loch na h-Achlaise is a popular location for getting the surrounding mountains reflecting in the water. When I arrived I could see clouds approaching from the southwest. As I drove the length of the loch, I discovered that most of it was frozen over except for one small section at the far end. I quickly found a foreground with an interesting finger of snow-covered shoreline that made an irregular line.

Wista Field 4 x 5; 90mm lens; polarizing filter; Fuji Velvia

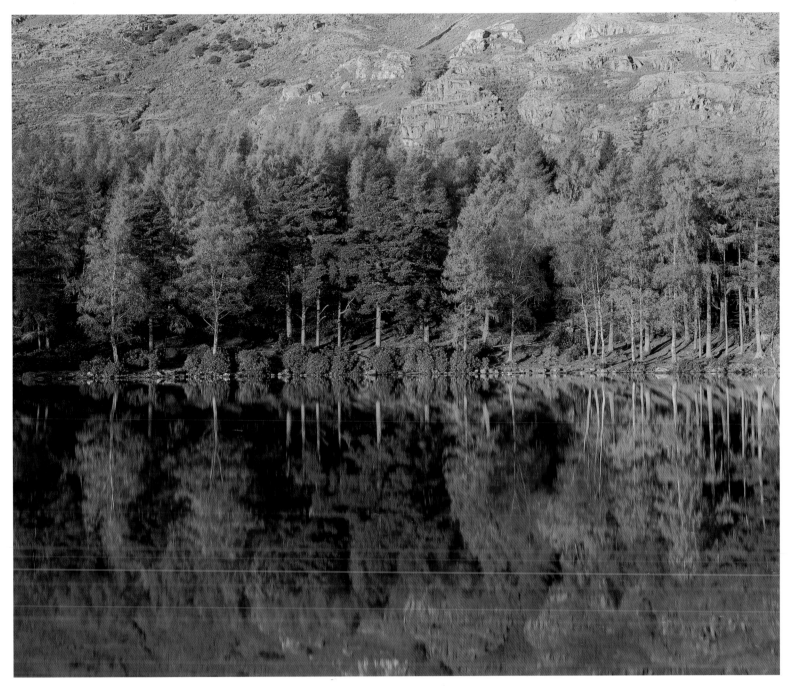

subject (blue sky will give a good average reading). I then compare the two. I don't like the subject to be any more than 1 stop brighter than the reflection; if it is greater I will use a neutral-density graduated filter over the main subject to even out the contrast (see also page 121).

Light is changed by two major factors: direction and intensity, and these qualities will determine the appearance of your subject. Train your eye to be aware of them both, but know the differences between seeing and photographing. Becoming adept at identifying the implications of these aspects of light on film is a crucial factor in making that essential creative leap from what you see to what works as a successful photographic image.

Autumn trees reflecting in Blea Tarn, Cumbria, England
Reflections give increased possibilities for additional compositions from one location. By picking out details from the larger scene (opposite), I concentrated on the lines of the trees and their reflections.
Wista Field 4 x 5; 210mm lens; polarizing filter; Fuji Velvia

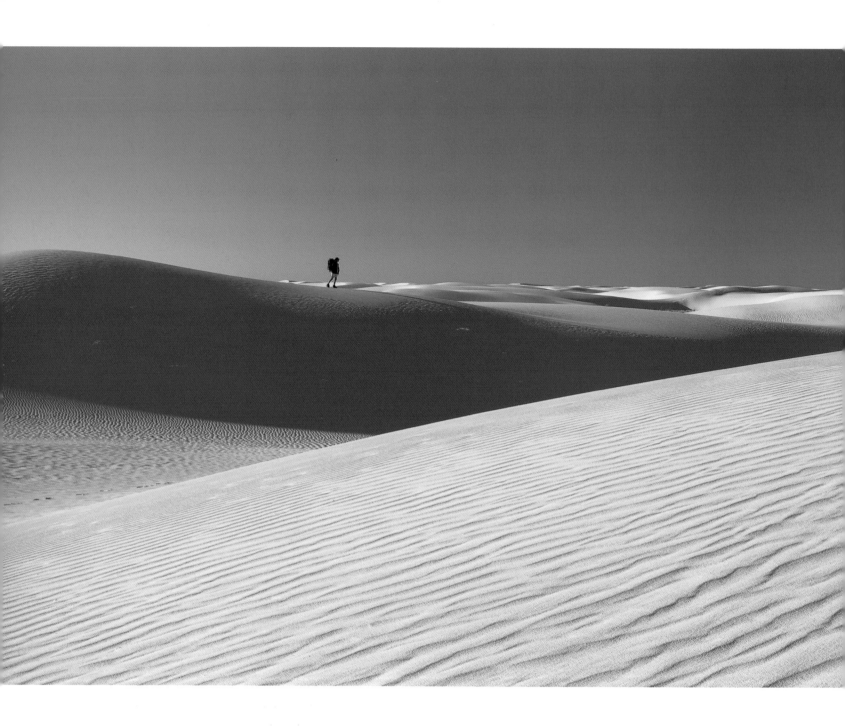

designing the image

Hiker on dunes, White Sands National Monument, New Mexico, USA

When I set up to photograph the gentle sloping patterns of the dunes, I felt that the composition needed a small human presence. I asked my friend to walk down the ridge of the dune and had him stop at about one-third of the way into the scene. He gives the image a sense of scale and feeling of desolation. Fuji GX617 panoramic; 90mm lens; polarizing filter; Fuji Velvia

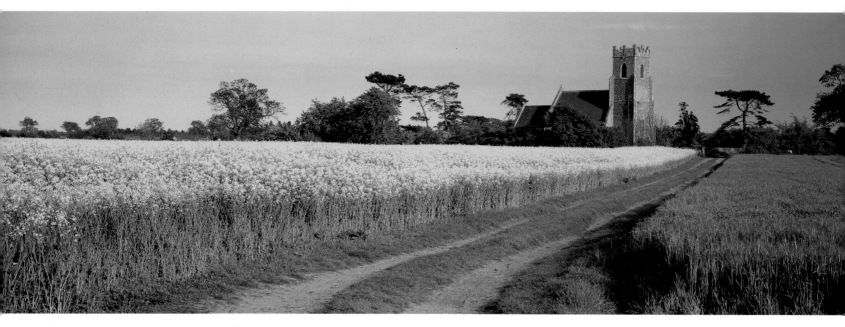

Church, Norfolk, England

With the church two-thirds of the way across the frame, I used the diagonal line of the track to lead across to it. The bright yellow of the field acts as a natural line that also directs the viewer to the subject.

Fuji GX617 panoramic; 90mm lens; polarizing filter; Fuji Velvia

Good composition, or the arrangement of elements within the picture frame, is vital to the task of achieving high impact. Images that have balance, order and rhythm are pleasing to the eye. Designing an image is rather like putting together pieces of a jigsaw puzzle – if one element is either missing or in the wrong place the final result will fail. As we have seen, good light is also vital. A technically perfect composition is lifeless without good light, and, equally, an image with fantastic lighting on an unstructured subject will not hold together.

There are some basic rules of composition that it is helpful to understand. These concern the aspects that go to make up a strong composition: balance, line (whether straight or curved), how to divide up the frame and depth of field. You also need to consider the role of people in the composition, or perhaps whether you want there to be an abstract element. However, these rules are not rigid (in fact they are probably better thought of as guidelines) and you can, of course, create images that have great impact but don't follow the rules. If the final image expresses what you have set out to achieve, and it holds the viewer's eye, then you have succeeded.

If you have an attraction to a scene, it needs to be analysed. It is important to ask yourself what it is about the scene that makes you want to take a picture (see also page 12). Then, set out to compose the image in a way that exploits this factor. As a photographer, I find that I can never switch off and am always looking at the world around me, organizing and cropping shapes and colours

Houses and cottonwood trees, Yellowstone National Park, USA

The white line of the kerb perfectly underlines and carries the viewer through the patterns of the houses and trees.

Wista Field 4 x 5; 150mm lens; polarizing filter; Fuji 50D

within a frame. From the moment you put a frame around your scene, you are consciously organizing it. If any element within this organized composition does not fit with or reinforce the rest of the picture, the viewer tends to see the image as lacking harmony, and mentally discards it. To take a simple example, many photographers forget to look at the edges of the frame to make sure that no unwanted elements are encroaching into the picture area or that no important elements are bleeding out of the frame. Learning simple habits such as checking the edges of your frame will make huge, instant improvements to your composition.

BALANCE

The basic techniques of composition can be learned but, beyond them, an intuitive response to the subject needs to come into play. I know several photographers who have not had any formal photographic training but their images are brilliantly composed; it could be said that their creation of balance has become automatic.

The word balance implies equal weight. Visually this would translate into absolute symmetry, but of course this is not how it tends to work best in an image. Usually, placing your subject off-centre will be more dynamic, leading the viewer's eye around the picture. The balance is instead created by using another feature for contrast. This is ideally of a different size, shape or colour. Two shapes of equal size compete for attention, in effect cancelling out the interest in each other as the emphasis is lost. Two unequal shapes take the viewer's eye across the picture plane from one to the other.

Colour contrast helps here as you could, for example, balance a large, pale area against a small strongly coloured detail, and vice versa. In the case of the Norfolk church (opposite, above), the building on the right is balanced by the yellow rape and the beginning of the track in the left

Vineyard and cypress trees, Tuscany, Italy
The simple lines of the grape vines and trees make a good pattern. I used a telephoto to compress the perspective and isolate just the lines, excluding the top of the hill. To include the hilltop would have weakened the overall impact.
Pentax 6 x 7; 200mm lens; Fuji Velvia

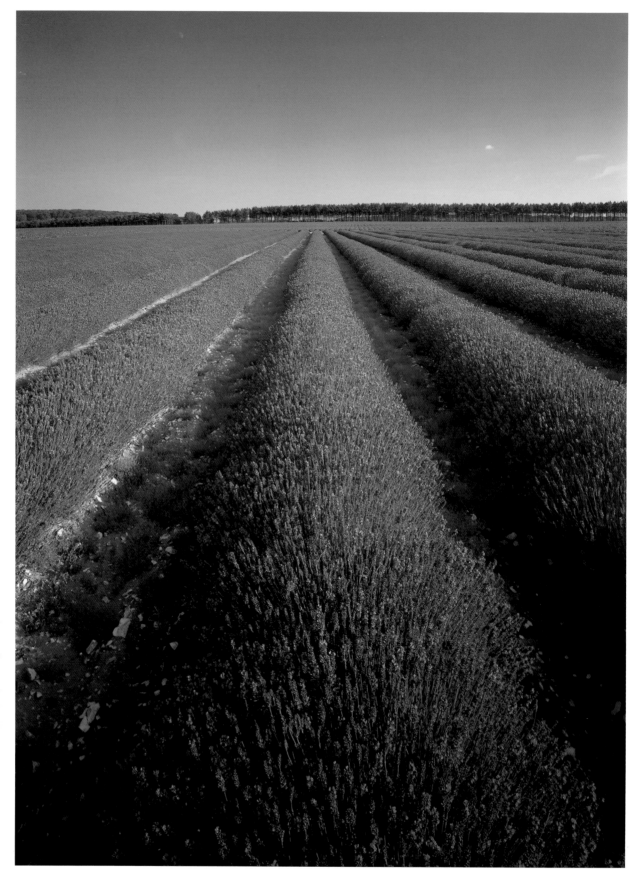

Lavender field, Norfolk, England

Using a wide-angle lens helped to accentuate the diagonal lines of the lavender rows. I straddled the centre row in order to keep the scene symmetrical and balanced. This line pulls the eye from the foreground into the picture. I set the horizon line at the top third of the frame because the main interest is the lavender. There was no reason to put any emphasis on the sky. The horizon line provides a conclusion to the scene.

Wista Field 4 x 5; 90mm lens; polarizing filter; Fuji Velvia

foreground and leading to it. In the Tuscan vineyard (see page 67) and the lavender field (opposite), on the other hand, I have used vertical symmetry to balance the composition, but horizontally the picture area is asymmetrical, and the focus of both pictures is the strong horizontal nearer the top of the frame. The eye is led by the clearly converging lines to this point in the picture. For more details about dividing up your picture frame, see pages 71–2.

LINE

Both the vineyard and the lavender field photographs demonstrate the use of very strong lines to lead the eye. Good placement of a natural line can very effectively focus attention on your subject, connect different areas of the image together, or create movement and depth. As photographs communicate information, or tell a story, their lines help to guide the viewer through them. The lines not only give directions, but can imply action and provide drama. In fact, the linear direction affects the overall mood of the image. A diagonal road in your image will be more interesting and exciting than if it went straight

Towering aspens, San Juan Mountains, Colorado, USA
The unusual angle from which these trees are photographed draws attention to their natural lines. Your eye is forced to the centre of the frame to the colourful canopy. In order for the image to work, I spent a great deal of time searching skywards for the right symmetrical distribution of trees with a good dispersion of yellow leaves. A polarizing filter provided a saturated sky.
Pentax 6 x 7; 45mm lens; polarizing filter; Fuji Velvia

Petrified sand dune striations, Paria Wilderness Area, Arizona, USA
This amazing rock formation has natural S-shapes that glide diagonally through the image. The bold lines entering from the lower right-hand corner help to draw the viewer into the image to the formations in the background.
Wista Field 4 x 5; 150mm lens; Fuji Velvia

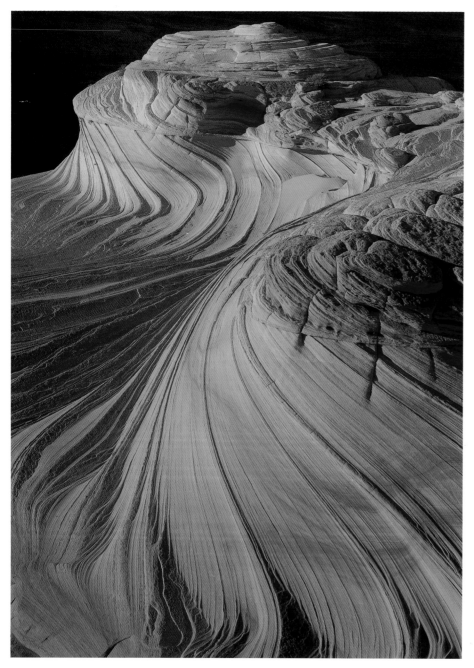

across the frame. This is because diagonal lines impart a feeling of motion and vitality – they seem to be rising or falling, or moving away from or towards the viewer. They instil your image with a vigour that vertical and horizontal lines do not.

A natural horizon line, on the other hand, tends to have a calming and tranquil effect within a picture. Where you place a horizon line gives emphasis to a particular part of the image; if it is placed towards the bottom of the frame, importance is given to the upper part, and vice versa. In the larger part of the frame, include a subject that captures attention or plays an integral part in the rest of the composition.

If the horizon line is placed across the middle of the frame, equal importance is given to the upper and lower halves. This creates tension because the eye keeps moving back and forth, not knowing which half of the frame is more significant. One example where this does work well, however, is with a reflection: the perfect symmetry of a reflection can make a powerful image.

CURVES AND S-SHAPES

Winding through a composition rather than dynamically cutting through it, an S-shape or winding curve is very appealing to the eye and creates natural balance. It is ideal for leading the viewer through the image, passing all the elements you want them to notice along the way. The most obvious examples are curving paths, roads or rivers, but it is also possible to obtain the same effect using the more subtle curves and S-shapes made by light and dark areas in a scene. Shadows cast from the natural contours of the land will direct the eye through the frame, as will the placement of objects that follow a curving line.

A dynamic straight line tends to be direct, harsh and to the point, but a gentle curve is characterized by a flow that is graceful and pleasing. In the image of the Paria

Wilderness Area in Arizona (opposite), multiple lines create an elegant pattern and lead into the picture and up to the formations in the background. Complementary lines assist the main sweep of the composition, reinforcing the direction in which the eye is being guided through the image. In the shot of the path through wild garlic (below), the secondary line coming into the frame from the left also functions as a supporting line. Multiple lines serve to strengthen an image. But be sure to place them carefully when designing your image as too many lines that are not pertinent will confuse the viewer.

DIVIDING UP YOUR PICTURE FRAME

The way that the picture area is divided up is important because these basic proportions make the first impression on the viewer. The most pleasing balance frequently happens when you divide up the picture frame unequally. Known as the 'rule of thirds', this is a simple and helpful guide to dividing the frame both horizontally and vertically into thirds and placing your principal subject at any one of the four lines that intersect.

The rule of thirds is really a practical interpretation of the golden section, a 'divine' proportion that is particularly

Snow-covered pines and stream, Flagstaff, Arizona
S-shapes don't always have to be obvious. I used the subtle line of the stream to lead the viewer into this scene. The dark shape of the water against the white snow winds naturally into the picture.
Pentax 6 x 7; 45mm lens; polarizing filter; Fuji Velvia

Path through wild garlic, Fife, Scotland
The gentle S-shape of the path has a much better feel than one that just moves through the image in a straight line.
Fuji GX617 panoramic; 90mm lens; Fuji Velvia

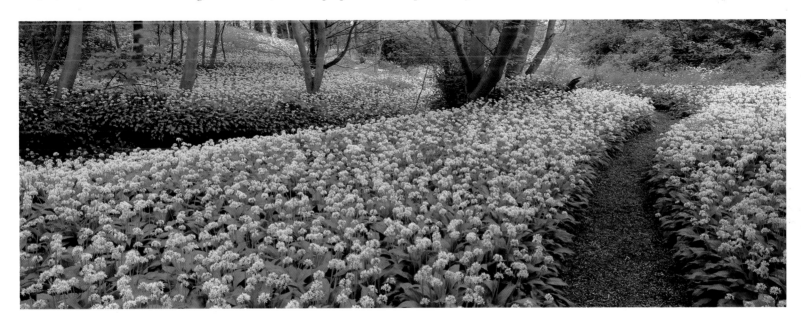

Tree in barley field, Wiltshire, England

I divided the panoramic format into thirds and put the tree into the right-hand third. The barley field and tree are the main focus of the image. Importance is given to the barley field by giving it two-thirds of the frame; the tree is a focal point.

Fuji GX617 panoramic; 90mm lens; Fuji Velvia

pleasing to the eye and has been used by artists, architects and mathematicians since the earliest civilizations. Very simply put, the golden section is a line dividing a rectangle into two parts (roughly one-third and two-thirds) so that the ratio of the smaller section to the larger section is exactly the same as the ratio of the larger section to the whole. The amazing thing about it is that so much of nature obeys this simple rule of proportion. In many plants and trees, for example, the branching point of the first branch in relation to the overall height occurs at exactly this point. The mathematical sequence derived from the proportion governs the growth of all sorts of things from the arrangement of petals on a pine cone to the unravelling spiral of snail or sea shells. It is a complex, fascinating subject, but it is enough from a photographic point of view to know that it works, and the knowledge that it occurs so often in nature goes some way towards explaining why a composition looks comfortable and balanced when arranged according to the proportion.

Placement of a horizon line is important for the application of the rule of thirds. With the horizon in the middle of the frame, it is difficult for the viewer to decide where the main focus of the image lies, in the top half or the bottom half (see page 70). Placing the horizon either in the bottom third or the top third of the frame changes the emphasis on foreground, midground, horizon and sky. In the photograph of the barley field (above) I have placed the horizon high, giving greater emphasis to the field, which is jointly the subject of the picture along with the tree, which in turn is placed roughly one-third of the way in from the right side. The contour of the field provides a further prominent line, which I have placed roughly one-third of the way up from the bottom of the frame. This image also shows that the rule of thirds can be applied whatever format you are using, including panoramic, as in the case of the barley field, or large format (opposite), as well as 35mm.

DEPTH OF FIELD

As well as organizing your composition within the frame, making the most of the technical capabilities of your equipment is an important part of designing an image. To make a two-dimensional medium appear three-dimensional, you can manipulate the depth of field, bringing all points of the image into sharp focus. Technically speaking, depth of field is the distance between the nearest and farthest point of the subject that is acceptably sharp in an image. There are three aspects

Hellington Church, Norfolk, England
The line of the hay bales, along with their shadows, directs the viewer to the subject – the church – which is placed on the intersection of the top and left thirds.
Wista Field 4 x 5; 150mm lens; Fuji Velvia

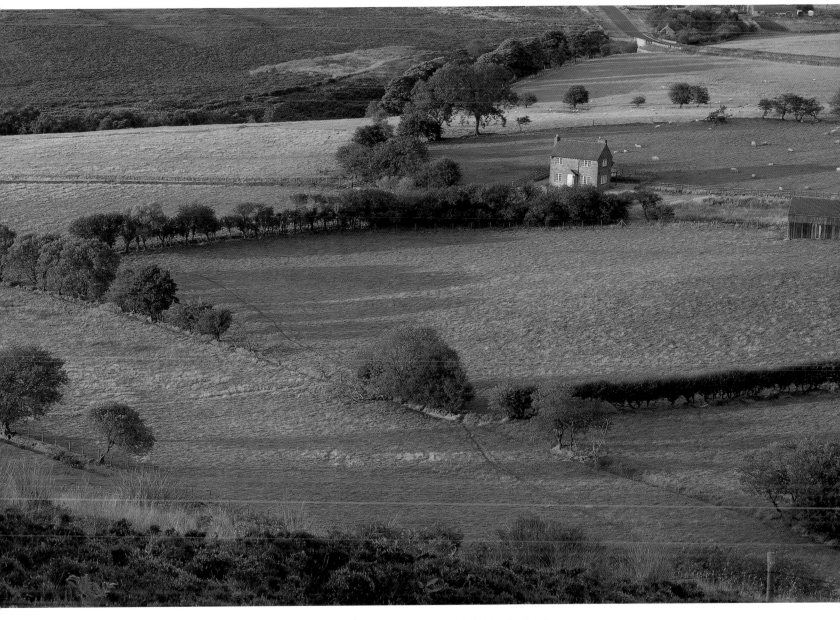

Cottage on the moors, Yorkshire, England

I placed the cottage in the last third of the frame and used the sweeping, dark foreground to lead to the hedge, which leads to the cottage. The composition wouldn't have been as effective if the cottage had been in the centre or on the left of the frame. There are multiple lines within the composition that work together to create a large subliminal S-shape that eventually ends at the cottage.

Fuji GX617 panoramic; 180mm lens; Fuji Velvia

Rhododendrons, hostas and waterfall, Kent, England

A prominent foreground, midground and background can give a three-dimensional feeling to an image. I used a front tilt on my view camera to bring the hostas in the foreground into sharp focus, while keeping the background sharp, too.

Wista Field 4 x 5; 75mm lens; Fuji Velvia

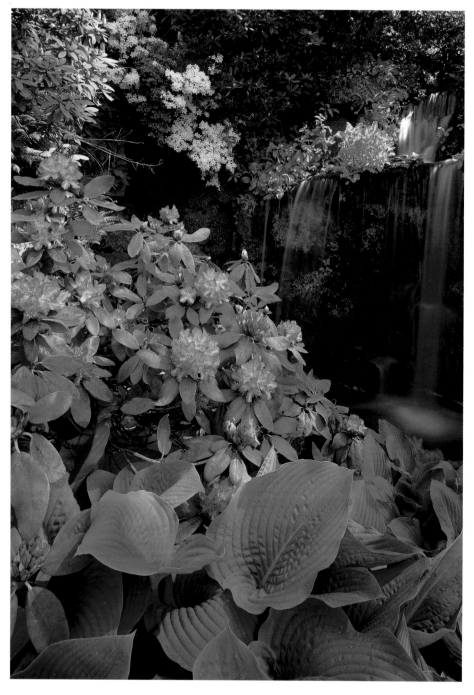

that determine depth of field: the focal length of the lens, the aperture, and the focusing distance. A shorter focal-length lens, such as a wide-angle, has greater depth of field than a telephoto. Using a smaller aperture will increase the depth of field within an image. The farther away the subject is from the camera, the greater the depth of field will be.

Landscape photographers are probably among those who manipulate depth of field to the greatest extent, aiming for sharpness across the whole image. The 'near-far' technique of using a wide-angle lens to render from the foreground to infinity in sharp focus is particularly popular. This gives viewers the impression that they can walk right into the image.

One of the benefits of using a view camera, as I do for most of my work (see page 139), is the immense control you have over the image. A view camera is a large-format camera where the image is viewed upside down and backwards on a ground-glass screen at the film plane. It is basically a piece of glass on the front of a light-tight box with a piece of acetate film on the back. There is no auto-bracket feature, automatic film advance or different metering modes. In fact, there is no meter, and the film advances as quickly as I can shove the film holders in the camera and pull the dark slide. The lens and the film planes can both tilt independently of each other; they do not have to remain parallel as in most other cameras – in fact they are designed to tilt to offer a huge range of focusing opportunities. When it comes to adjusting depth of field, tilting the front lens axis of the camera and adjusting the focus rail can achieve total overall sharpness of the image. You might use this tilting mechanism to compensate for the converging lines of a building rising above you when photographing architecture, for example; or you might tilt the lens downwards when photographing a natural subject, such as a stream or vegetation below you (left). You

Canyonlands National Park, Utah, USA

The juniper wood was used as foreground interest to give a strong sense of depth using a wide-angle lens. The placement of the wood in the lower left corner balances the bell-shaped rock in the background.
Wista Field 4 x 5; 90mm lens; polarizing filter; Fuji Velvia

Venice Carnivale, Italy

I used a long lens with shallow depth of field to isolate the subject from the background. I felt it was important to keep the Gothic arches vaguely recognizable to give a sense of place. The railing acts as a good leading line with the subject facing into the frame.
Pentax 6 x 7; 200mm lens; Fuji Velvia

can see what is in and out of focus quite clearly on the ground-glass screen.

Other camera formats have to rely on using hyperfocal distance to achieve a similar effect. Hyperfocal distance is the point nearest to the camera that gives acceptable sharpness at a given aperture when focused at infinity. When the camera is focused on the hyperfocal point, the depth of field extends from a distance halfway between this point and the camera to infinity. I'm not going to quote confusing formulas to calculate the hyperfocal distance. Basically, you focus one-third of the way into the scene and begin by stopping the lens down to the optimum aperture of the lens, usually f16–22, then check the hyperfocal marks on the barrel of the lens to make sure the chosen aperture covers from the closest focused area

to infinity. If you have a depth-of-field preview on your camera, this can be used to see if all areas of the subject are in sharp focus. Find out the optimum aperture of a lens by referring to the manufacturer's lens specifications. One word of caution: when stopping the lens down beyond the optimum aperture, even though the depth of field is increased, the overall image resolution is reduced due to an effect called image diffraction.

The Grand Tetons, Wyoming, USA

When I was composing this image, the sky didn't have any interesting clouds and the foreground material was non-existent, so I used a dead tree on the shoreline to frame the Tetons and fill the foreground with a striking element.

Wista Field 4 x 5; 90mm lens; polarizing filter; Fuji 50D

These two images show the importance of being aware of the whole scene. I noticed the shadows of the Gothic arch beautifully framing the subject. Using a wide-angle lens, I quickly photographed him before any tourists could interfere with the scene (right, above). Then I came in closer to capture him and his shadow (right, below).
Pentax 6 x 7; 45mm lens (right, above), 135mm lens (right, below); Fuji Velvia

Using a shallow depth of field can also be a useful technique to draw attention to the subject and make it stand out from the background. You will need to use a telephoto lens with the aperture fairly wide open, depending on the required end result you're looking for. I sometimes use this technique for travel shots, throwing the background out of focus so it does not distract from the subject, but is recognizable enough to give a sense of place.

FRAMING

When designing an image, including a framing device in the picture can be an effective way of balancing and emphasizing your main subject. It can also be useful for hiding unwanted elements. Using a foreground frame such as the dead wood (opposite) has the effect of putting the viewer more in the picture. It is as if we are peeking through the branches across the lake to the mountains rather than accepting the photographer's rectangular frame. A similar effect is achieved in the view of Yosemite National Park (see page 81). Placing your frame in the foreground like this also adds depth to the composition.

Conversely, if you use a framing device such as a window or doorway further back in your composition, it will tend to isolate the subject within it, like the Pierrot in Venice (right). The shadow of the Gothic arch picks him out and takes everything outside the illuminated arch out of the picture altogether. When I come in close, although the focus is obviously still on him, the composition sits within the whole frame of the photograph. It is also

interesting to notice how much more important his shadow becomes in this composition. In the top picture you hardly notice it, but in the bottom one, it is competing for our attention with the Pierrot.

Photographing urban landscapes or architecture can be a challenge when cranes, power lines, television aerials or scaffolding get in the way. Framing the subject with trees or sculptures in the foreground can hide these unwanted intrusions as well as bringing attention to the main subject. I've often used a low angle of view from behind flowerbeds or fountains to hide cars and rubbish bins in urban landscapes. Similarly, wild and empty landscapes do not always provide the perfect picture in themselves, and you can use overhanging foliage or rock formations in the foreground to conceal a telegraph pole or to cover up a gloomy grey or cloudless sky.

National Gallery, London, England

It's becoming more and more difficult to photograph cities without getting at least one crane in the picture. Such was the case here, but I chose an angle that framed the National Gallery with the fountains and also covered up the crane. As the crane was constantly on the move, timing was crucial to conceal it behind the water coming out of the fountain on the left.

Wista Field 4 x 5; 90mm lens; polarizing filter; Fuji 50D

Merced River reflections, Yosemite National Park, California, USA

Using the tree to frame the Merced River helped to hold the composition together. The sky wasn't too interesting, so having the silhouette of the tree branches keeps the viewer's eye from drifting out of the picture.

Wista Field 4 x 5; 90mm lens; Kodak Ektachrome 64

Fell Foot Farm, Cumbria, England

This image, taken in the Lake District, is ideally suited for the panoramic format (top). It retains just the right amount of compositional elements without becoming too overcrowded. The smoke coming from the chimney adds the perfect final touch. The 4 x 5 image (above) has too much needless information. The dark shadow cast from the stone wall is too heavy and distracts from the tree and farmhouse.

Fuji GX617 panoramic; 90mm lens (top), Wista Field 4 x 5; 150mm lens (above); polarizing filter; Fuji Velvia

FILM FORMATS

The type of film format that you decide to use substantially determines the way you compose your images and, to a certain extent, impedes your creativity. This is one reason why I choose to use several different formats. I find that certain scenes need a panoramic as opposed to a rectangular format. When the panoramic format first became popular, many photographers used it on any and every scene, but it doesn't always work well. Likewise, there is not necessarily one format that works best for a particular scene; there are many ways a scene can be photographed and each one will have a completely different feel. Every element of a composition needs to be arranged according to the shape of the frame or format.

A good case in point is the square format. This is very different from the traditional rectangular format, and difficult to work with. You have to compose your photograph specifically for the square. The way we see things naturally is more suited to a rectangular, landscape format – we scan across a scene with our eyes. Using a square involves restricting our point of view.

An easy solution to using different formats might seem to be to crop the image afterwards. Unless it is not technically possible at the time of making the photograph, I feel

the photographer should use the chosen format to the fullest. (The only time I leave large sections of a frame vacant is when I know that text or a title needs to go there.) Cropping with the camera as you take the shot, rather than at a later stage, will make you more conscious of the elements that produce strong compositions. Also, from a practical point of view, when I mount the transparencies into presentation mounts to show clients, they tend to be standard sizes and will not reflect a particular cropping that I may have intended to give an image. Even if I mask the mount down, it will be inconsistent with the rest of my work and, when it goes to the reproduction stage, there is no guarantee that they will maintain my cropping.

The view of Oxnead Mill on the River Bure in Norfolk (see pages 84 and 85) demonstrates how different film formats can affect an image. Two quite dissimilar compositions result. In the 4 x 5 format (page 85), the river bank in the foreground curves strongly to bring the viewer's eye around and towards the mill, which is placed in the upper left of the composition, according to the rule of thirds. The panoramic shot (page 84) uses a

Country lane in winter, Norfolk, England
Composing for the square format requires the placement of elements to use the whole frame. I composed this image to show the road winding through the trees. Cropping would not make the image stronger, and would defeat the purpose of using a square format. Hasselblad 500C/M; 80mm lens; polarizing filter, 81A warming filter; Fuji Velvia

strong diagonal line coming in from the right to meet the long line of trees that dominates the picture. This diagonal is emphasized by the two horses that have now moved into view to lend some animation to the scene. The more prominent shape of the fence in the left foreground has a greater role to play in this composition in balancing the scene with the poplar trees.

The hoar frost conditions of this scene are really perfect for getting good photographs. Occurring when there is a large amount of moisture in the air, such as mist or fog, and when the overnight temperature drops sharply below freezing, the frost is formed when the fine water particles freeze and attach themselves to everything, creating a frosty sugar-coating. Because hoar frost occurs only in

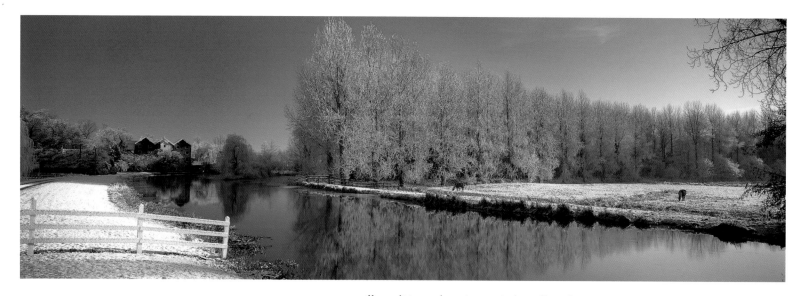

very still conditions, there is no wind to affect the composition. And if the weather front that brought the moisture moves away by dawn, chances are good that you will be rewarded with a clear blue sky to contrast with the white frost. The frost can melt very quickly, though. You can see from the two shots on these pages that it has started to melt – the 4 x 5 was done first, and the frost is whiter and brighter in this shot than in the panoramic. For more on anticipating atmospheric conditions when photographing, see pages 56–7.

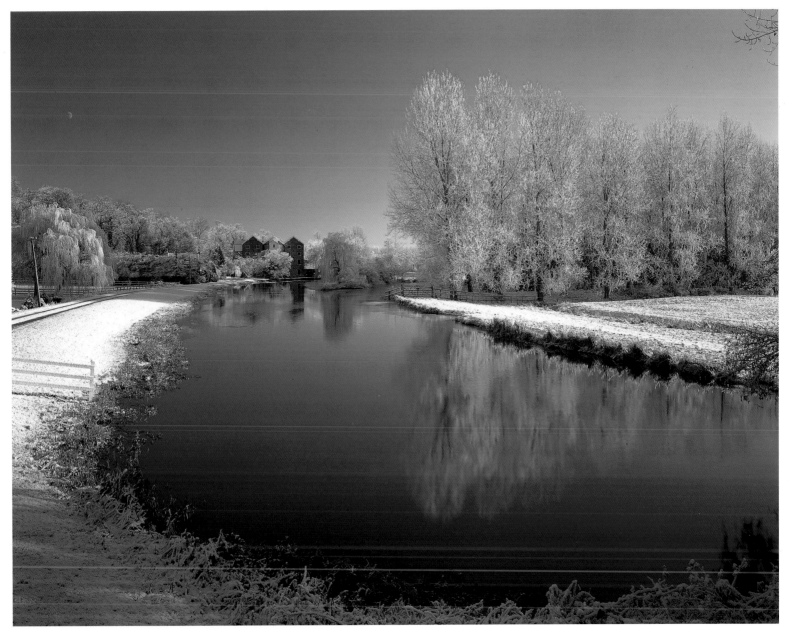

River Bure in frost, Norfolk, England

This scene works equally as well in panoramic as it does in a rectangular format. The line of poplar trees balances with the fence in a linear composition (opposite), while the second image (above) takes on a completely different feel in a rectangular format, with the river and mill more prominent.

Fuji GX617 panoramic; 90mm lens (opposite), Wista Field 4 x 5; 90mm lens (above); polarizing filter; Fuji Velvia

TOWARDS ABSTRACTION

Abstraction is a deviation from reality. Compared to many forms of art, photography is supposed to be a realistic medium, to record what is there. But as soon as you choose a particular lens or type of film you are changing that reality. When you compose a scene, you are deciding what you want your viewer to see and not see. The way you use your camera, accessories and film will control what is in and out of focus, the intensity of the colour, the light and shade. In short, you can take reality and turn it into abstraction. Looking at the world around you with this in mind, you will uncover images of semi-abstract or abstract form everywhere you turn. Finding these images can be very challenging and most rewarding. I have already covered how to develop your ability to 'see' images by searching out patterns, shapes and colour within a wider context (see pages 10–35). Designing images towards the abstract is much the same: you are looking

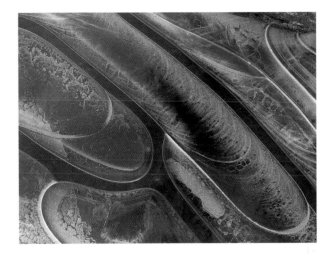

Ice design

A simple image of ice patterns needs careful composing. I positioned the fingers of ice diagonally across the frame to imply action, keeping the longest curve from breaking outside the frame.
Wista Field 4 x 5; 210mm lens; Fuji Velvia

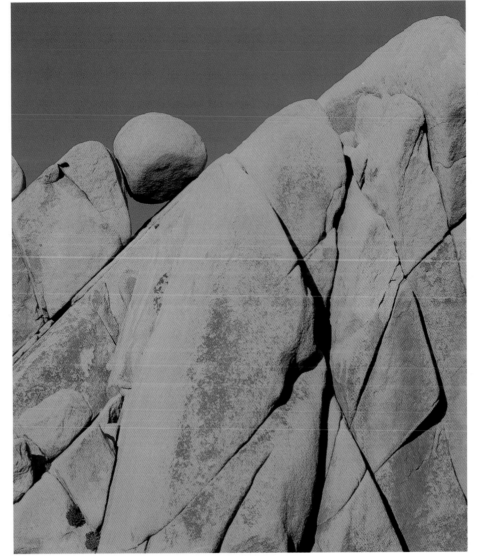

Street lights, Bilbao, Spain

I created an abstract image by positioning the camera directly under the menagerie of street-lights, omitting any horizon, which would have added a sense of reality. Careful positioning brought the chaos of the numerous posts into a symmetrical order.
Pentax 6 x 7; 45mm lens; polarizing filter; Fuji Velvia

Jumbo Rocks, Joshua Tree National Park, California, USA

The natural landscape has many abstractions. Using a telephoto to come in close to the rock shapes here, and omitting any plants or people, there is no association with size. I like the natural diagonals of the rock face and delicate balance of the wedged boulder in this graphic image.
Pentax 6 x 7; 200mm lens; polarizing filter; Fuji Velvia

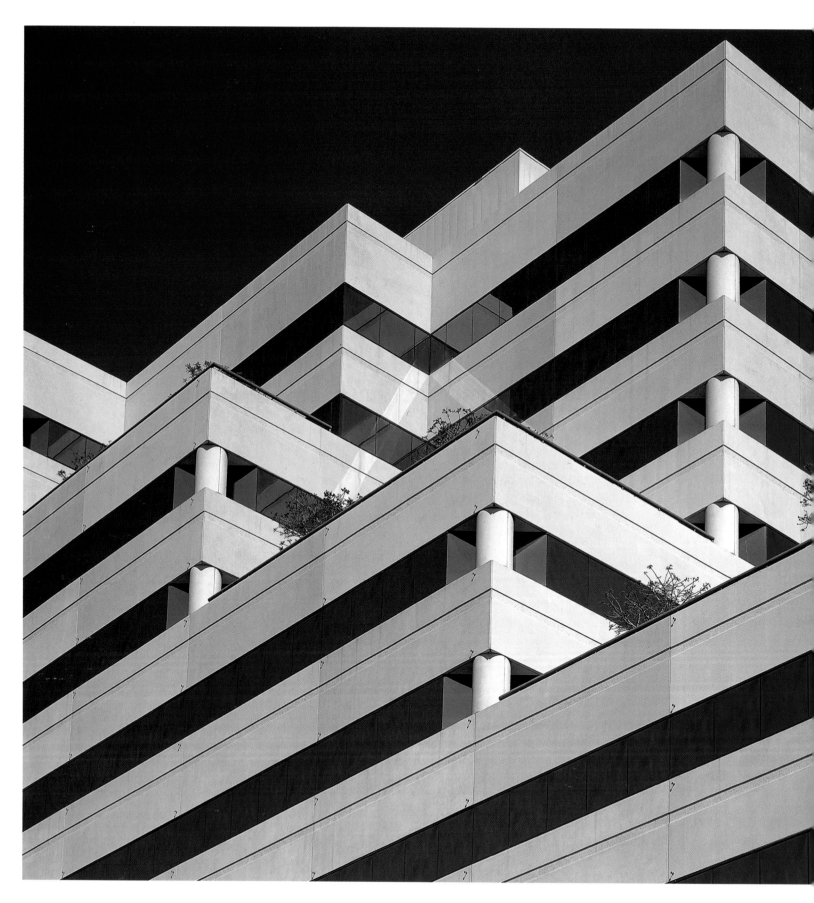

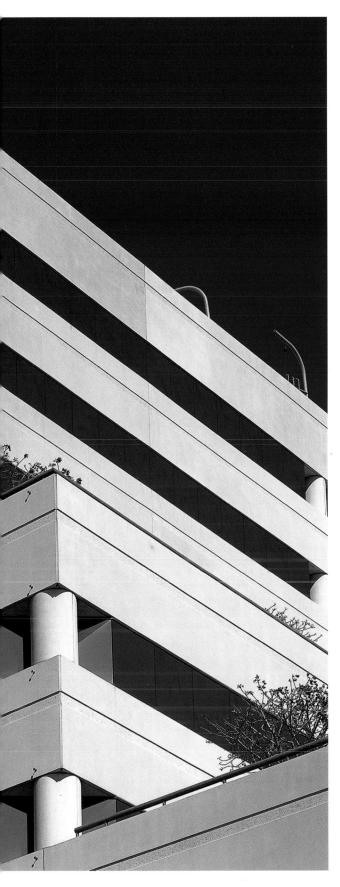

to compose your photograph so that a striking design is isolated from its environment in such a way that it is no longer instantly recognizable. Subjects that make good abstracts are limited only by your imagination.

Changing your point of view from the obvious one is a good place to start. Try looking straight up to the sky as in the image of the Bilbao street lights (see page 86), or from a bug's-eye view. Macro photography can unleash a wealth of abstract subjects. I once saw a photograph that at first resembled a forest viewed from the air but, on closer inspection, turned out to be a close-up image of the inside of tree bark. That photographer had an exceptional insight into finding abstract images. When you continually look for abstract subjects, your perception of the world is heightened and the search becomes much easier. It's like seeing the world through the eyes of a child again: when we grow up, we unconsciously build barriers that cloud the mind, we are too familiar with the world and take many things for granted. When we see things for the first time, as children, we have no preconceptions of how things should be, we explore new ideas and put shapes together without preconceived notions of their meaning. My own children have helped me to renew the way I look at things. I try to study a scene and analyse it purely as a collection of shapes and colours and often find something new and surprising in it, such as the form of an animal traced in the interplay of shapes or a face in the outline of a shadow. Enjoy looking at things in a different way, without preconceived ideas.

As well as changing your viewpoint, change your priorities, and concentrate on colour rather than shape. We identify things largely by their outlines and setting, and striking abstracts can be achieved by framing a subject so that its colours, rather than its forms, are emphasized. You could try this by photographing a flower petal close-up. Other surrounding flowers and foliage will become an out-of focus splash of background colour, while the colour of the petal becomes the subject of the picture. You can also tilt the camera so that, seen from an unusual angle, the subject is less important than the colour. You can even have the subject out of focus in order to turn its shapes into areas of blurred colour (see also pages 109–13).

Building abstract, Glendale, California, USA
I isolated a section of the building to call attention to the lines and patterns and create an abstract image. The movements of the 4 x 5 camera enabled me to keep the columns vertical instead of converging. A polarizing filter was essential to build up contrast between the building and sky; it also takes the reflection off the mirrored windows, making them more uniform with the tone of the sky.
Wista Field 4 x 5; 210mm lens; polarizing filter; Fuji Velvia

THE ESSENTIAL INGREDIENT

The subject of a photograph can be the tiniest detail. It is your arrangement of this detail that makes it significant. You have only to look at the photographs below and opposite to see this graphically displayed. In each case, the photograph is not necessarily 'of' the little bush in the desert or the pair of cypress trees on the hill, but they are the essential ingredient in the composition. Everything else in the image revolves around them, and without them the composition would be blank and uninteresting. The subject is really the desert or the rolling field, but the point of interest expresses an emotion about the scene. It also gives the eye something to rest on and return to, and so organizes the whole image.

In the case of the desert, rather than focusing the viewer's attention on the patterns of the sand, the bush accentuates the vast and (mostly) featureless nature of the desert and, at the same time, emphasizes its dry, arid nature. Similarly, the cypress trees accentuate the expanse of unbroken rolling field in the image, and help to give it scale (or even exaggerate its size) – the trees so far away, tiny on the horizon, with nothing but empty field before them.

Something so small can have a tremendous impact on an image; it can be everything in a photograph. Its effect is like that of looking at a small, completely still lake reflecting the dusk sky. The scene is one of solitude, peace and tranquillity, but one small stone cast into the middle of the lake breaks this mood and creates tension. Your eye is at once directed to the ripples that radiate from the centre out towards the edges of the frame. This is the essential ingredient that is needed to complete the story, create new conceptual meaning, and give direction for the eye that might otherwise be left to wander aimlessly through the scene.

Sand patterns and bush, Namibia

Without the inclusion of the bush, this would just be another picture of sand patterns. The bush portrays the concept of isolation, strength, survival and solitude. I deliberately omitted the sky in order to eliminate other elements of the scene that would detract from the main focus.
Fuji GX617 panoramic; 180mm lens; Fuji Velvia

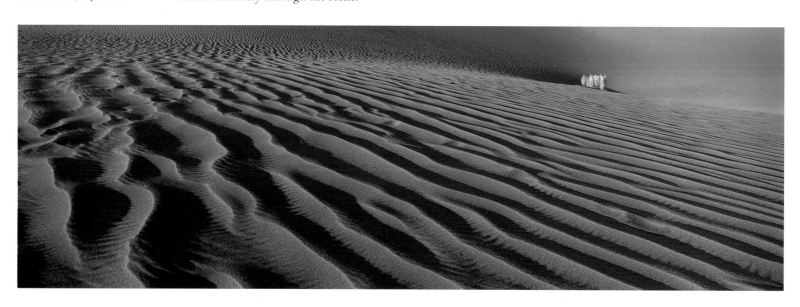

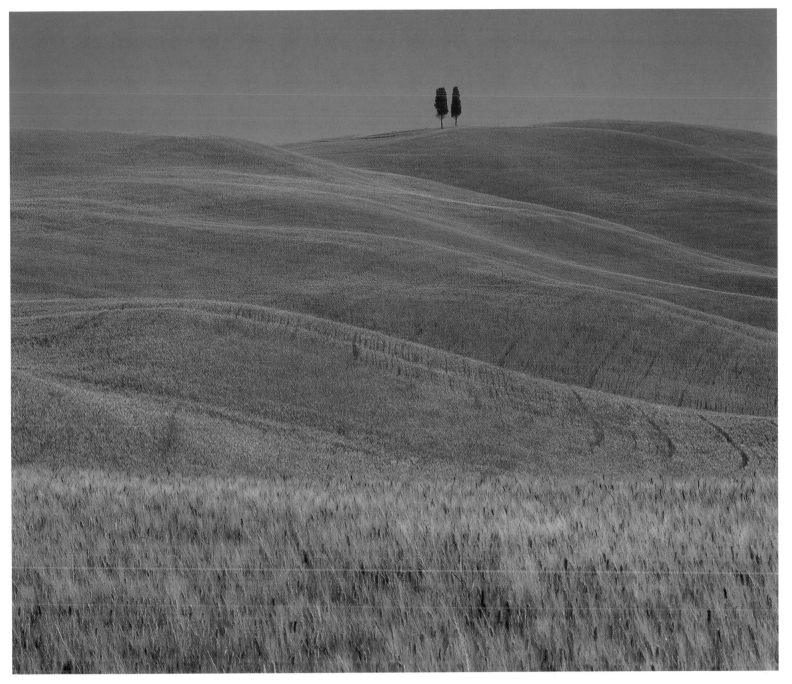

Rolling fields and cypress trees, Tuscany, Italy

The two cypress trees are an essential ingredient in this image because, without them, there would be no point of focus, and the whole concept of the image would change. The viewer's eye would wander around with nothing to settle on.

Pentax 6 x 7; 200mm lens; yellow/blue polarizing filter; Fuji Velvia

THE HUMAN ELEMENT

Ansel Adams was once confronted about the lack of people in his work. In reply to this complaint he stated that there were always two people, the photographer and the viewer. I, too, tend to work much better with the landscape or with buildings rather than people, but there are times when I need a human presence in my images. Often it is to provide a sense of scale to the main subject. For example, the viewer would have no idea of the size of a massive waterfall or tree without a known reference beside it. With the presence of a person or a couple, the viewer can identify more with the location as it is easier for them to imagine themselves there. I've photographed long corridors

Spiral staircase and masked figure, Venice Carnivale, Italy
The repetitive patterns of arches and columns of this spiral staircase make an interesting picture on their own, but I felt that they needed a human element to give them a main centre of interest. Without the person, the image has no focal point. When you cover up the person, your eye tends to move around and out of the picture, with no place to settle.
Pentax 6 x 7; 200mm lens; 81B warming filter; Fuji Velvia

of Gothic columns with seemingly endless patterns descending into the picture; the patterns alone are interesting, but not enough to keep the viewer's attention and it needs a person to complete the picture, rather like the essential ingredient mentioned on page 90.

When adding someone to my image, I tend to make them small in relation to the main subject. They then don't compete with the subject, but support it. It is hard to generalize about where to place people; it will, of course depend on your overall composition. But bear in mind the lines of your image and aim to position the person where they will enhance the flow of the image.

From a commercial point of view, it is always a good idea to include people in your images, reflecting various lifestyle activities, as this tends to make for very marketable stock images. Adding people has substantial advantages: it makes a tidier image of a more archetypal scene and it has greater aspirational appeal. Try to include people with the appropriate clothing for the picture (such as the two hikers on the right, who are wearing classic hiking gear), but for a picture to have a long shelf-life, look for people who are not dressed particularly fashionably so that their clothing is less likely to look dated in a few years' time.

This last point is a reason why I often don't include people in my landscapes unless it is essential for improving the composition. I have landscape images that are nearly 20 years old that are still making money for me as they are timeless and there is nothing to date them. If they included people, I suspect sales may have fallen off. One possible solution is to make two versions of a scene, with and without people, to cover every eventuality.

BREAKING THE RULES

With a good understanding of the basic rules of composition, it is possible to break them deliberately to great effect. Remember, they are only guidelines.

The Matterhorn with hikers, Zermatt, Switzerland
I photographed this image with and without people to increase its market potential. The image with the hikers has sold countless times, whereas the image without them has made only a few sales. I was careful to choose people with the right attire and colours to suit the location.
Wista Field 4 x 5; 150mm lens; polarizing filter; Fuji Velvia

Most of the rules of composition are based on creating balance and harmony, leading the eye through the picture and often to the subject. If this is not what you want to achieve, then it can be a very attractive option deliberately not to do it. This provokes tension in an image, which can, in turn, create strong impact.

There are circumstances when ignoring the rule of thirds, for example, can really make for a powerful image, such as placing the subject right in the middle of the frame. This literally centres the attention on the subject and can give a feeling of isolation or strength. Instead of placing the horizon on a third, try putting it right at the top of the frame with just a slice of sky showing. This will emphasize the importance of the subject in a large space.

Panoramic images can be used vertically to symbolize strength or power in a tall object, such as a tree or waterfall. For compositions to work vertically there has to be

sufficient interest to pull the viewer's eye all the way from the top of the frame to the bottom and vice versa. In the image of the Namib Desert (right), I have turned the panoramic upright to give a long, vertical sweep from the cracked mud at our feet up and over the dunes into the high clouds at the top of the picture. The horizon line at the centre of the composition divides it into two competing halves and our eye flits back to the bottom and up again. There is enough interest and texture at both top and bottom to hold our attention.

As with any composition, there must be thought behind an unusual arrangement. Don't break the rules just for the sake of it, but have a good reason for doing so. It is designing your images with careful thought that will lift them above the ordinary. Building pictures is therefore not a matter of obeying rules or following trends. It is about being aware of what is around you.

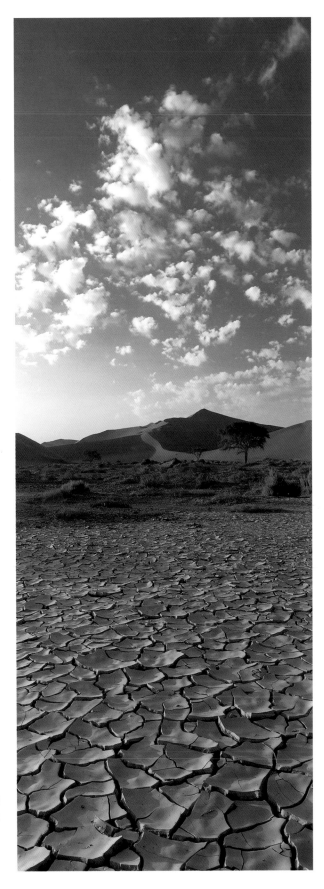

Cracked mud, Namib Desert, Namibia
This image demonstrates breaking the rules of composition that usually apply to a panoramic camera format. Most people immediately assume that a panoramic image will be a horizontal, but in some cases, the vertical format makes a more powerful image. It gives the feeling of being able to step right into the image.
Fuji GX617 panoramic; 90mm lens; Fuji Velvia

Field of rape, Norfolk, England
I purposely put the horizon line high in the top of the frame, breaking the rule of thirds. This gives the flowers more dominance and power. As the sky didn't have anything interesting to offer, there was no point including any more of it.
Wista Field 4 x 5; 90mm lens; Fuji 50D

colour and form

Burano, Venice Lagoon, Italy

The colourful houses of Burano are brightly painted so the fishermen can find their way home in the dark or in fog. The strong morning light helped to bring out the bold colours. I used a polarizing filter to increase the colour saturation.

Fuji GX617 panoramic; 90mm lens; polarizing filter; Fuji Velvia

olour is a factor of major creative importance in my work. As well as delighting the eye, colour can define form, set a mood and evoke emotion. Whereas black-and-white photography has to rely on tonality and composition to get a message across, colour introduces a more direct response. Colour in the landscape can tell us the time of year and the time of day. It has the ability to make us feel cold, warm, happy or sad. Yellows and oranges evoke feelings of warmth and well-being, blues chill and reds blaze. Just as uplifting colours have been used in the work place to improve productivity, so they can pick up (or bring down) the mood of a photograph.

Tulips, Lisse, Holland
Putting two bold colours together creates a contrast. The yellow tulip works well as a spot colour against the uniform red field, and can symbolize independence, strength and superiority.
Pentax 6 x 7; 200mm lens; polarizing filter; Fuji Velvia

HOW COLOURS WORK

The three main characteristics of colour are hue, tone and intensity. Hue is the actual colour wavelength, such as red, green or blue. Tone refers to the gradation of light and shade of a colour; tone helps to give the subject form. Intensity is the saturation of the colour, or how pure it is.

To develop the ability to use colour creatively you need to become aware of its emotional as well as its visual impact. This impact is all about the effect colour has on the viewer, which is often determined by the relationships between the colours themselves. Colour relationships basically fall into two categories: harmonious colours and contrasting colours. If you imagine white light (or sunlight) split into the spectrum, as you would see through a prism or in a rainbow, the colours line up, melting into one another through the finer grades, with red at one end and violet at the other. Join up the ends and you have a colour wheel on which colours that lie opposite each other (yellow and blue, for example) will contrast, and colours that lie near to each other (like orange and yellow or blue and purple) will harmonize.

Setting a stark contrast between colours will create tension and conflict in a picture, while composing a scene with harmonizing colours will, naturally enough, encourage a feeling of harmony, as in the image of the powerhouse (right). Individually colours can also have meaning and set a mood. The warm colours, as well as obviously promoting a feeling of warmth, are cheerful and 'up', while violet, indigo and deep blues at the other end of the spectrum are the opposite, appearing sombre or even giving a sense of foreboding. Greens are generally more restful and, by association with nature, can signify freshness, growth and life.

By using colours consciously you can change how the perspective appears in an image. Warm shades of red, yellow and orange advance in the picture frame, for example,

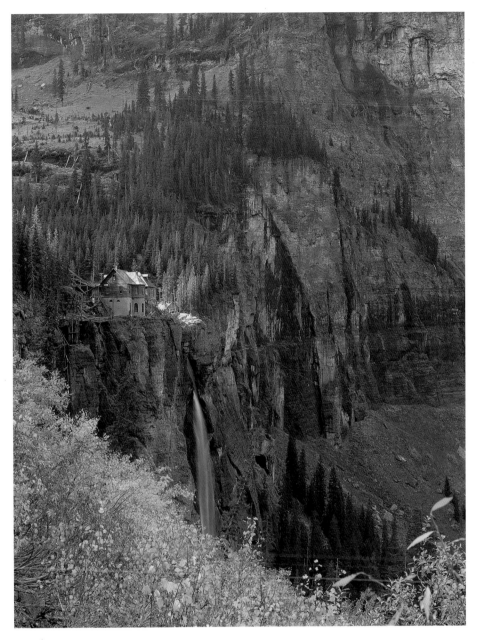

Old powerhouse and waterfall, Colorado, USA
The green, yellow and blue colours of this scene harmonize well to give a subtle impression that contrasts with the dramatic subject matter. The fragility of the old powerhouse perched on the edge of the cliff makes an arresting image. It has since been rebuilt, but unfortunately the new structure lacks the character of the old.
Wista Field 4 x 5; 150mm lens; Kodak Ektachrome 64

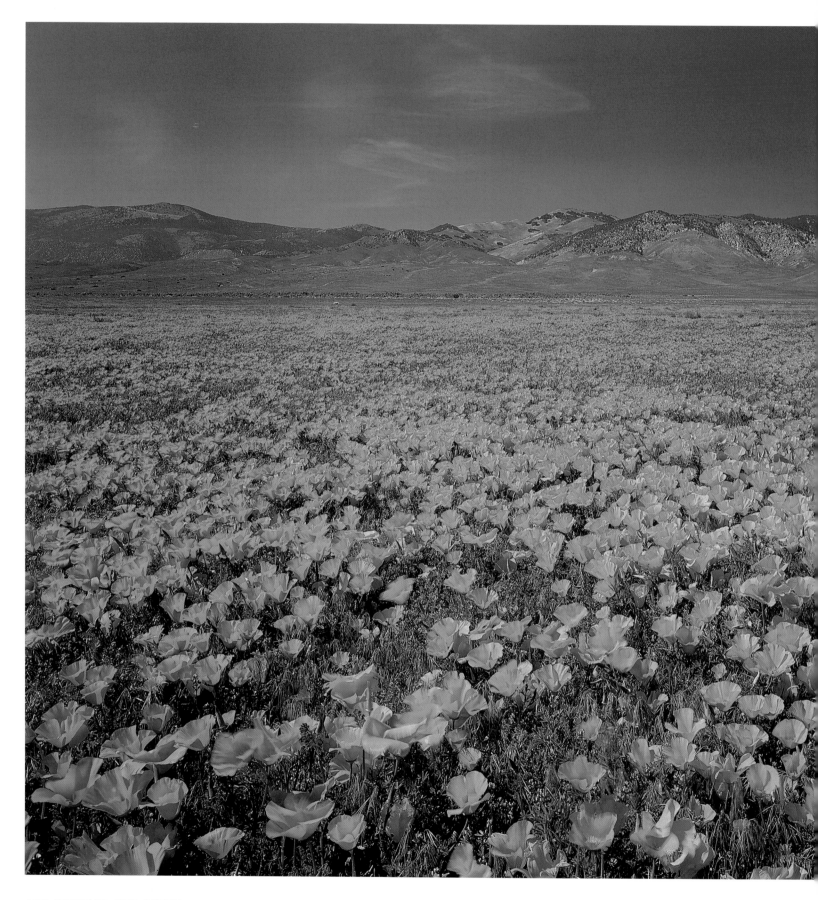

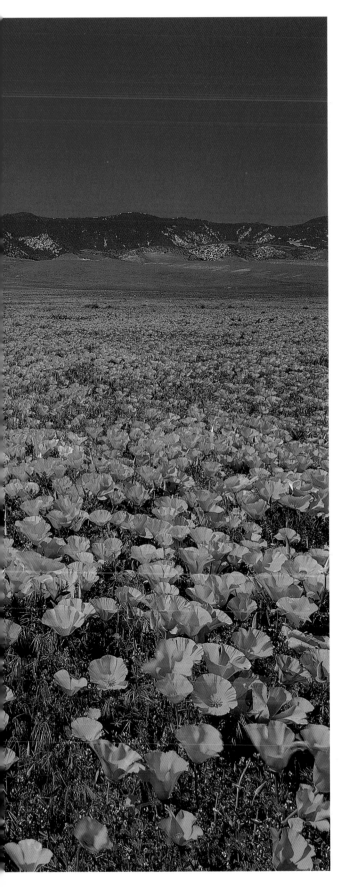

while cool shades of blue, green and cyan recede. Using saturated warm and cold colours together gives bold contrast in a photograph. For example, in an image of a red maple leaf against green moss, the red would advance and the green recede, making the leaf appear to jump out of the picture. This high visual impact is used extensively in advertising to attract attention.

BOLD COLOURS

There is a wealth of strong-coloured subjects around us, in both urban settings and the natural world. Pure and strong colours, particularly red, catch and hold the eye and demand attention, adding instant impact to a photograph. Simplicity of design is the key to capturing striking, bold colours, and very often moving in close to your subject will help you to achieve this.

I find the best times of year to photograph colour in the landscape are spring and autumn. During these two seasons, the sun is never very high in the sky, so the landscape is bathed in a warm light that casts long shadows for much of the day, revealing texture and depth. In the early spring this light brings out the richness of the new shoots of grass and freshly emerging leaves on the trees. The natural display of wild flowers comes to life in every location, from roadsides and meadows to deserts, and this provides opportunities to capture the fresh, new colour against a green field, or the one sprout of life in the barren desert. Cultivated fields of bright yellow sunflowers or daffodils against a deep blue sky provide an excellent colour contrast. In the part of England where I live, the drama of a bold yellow next to darker tones of green and blue can be found every year in the many fields of yellow oilseed rape.

The autumn landscape has a special appeal for photographers who seek to capture the breathtaking reds, yellows and golds of this short-lived season. One way to get the most from autumn is to follow the changing colours from north to south as the drop in temperature gradually bites further and further south. In North America photographers are able to extend autumn by starting in Canada around the second week of September and following the colours down through the Adirondacks in upstate New York, then through New England and continuing down as far as Georgia by the end of October.

California poppies, Antelope Valley, California, USA
The complementary colours of blue and orange work well here to make this image stand out. I used a polarizing filter to reduce the reflections on the flowers, increasing saturation. This was one of my first large-format landscapes, and it continues to sell to this day.
Wista Field 4 x 5; 90mm lens; polarizing filter; Fuji 50D

A shot such as the backlit orange leaves against a blue sky (below) is a perfect example of composing with contrasting colours for maximum effect. Using a polarizing filter will increase the saturation in the leaves and their contrast with the sky.

In winter the white snow-covered landscape can produce some surprisingly bold colours. Lakes and rivers surrounded by snow at sunrise or sunset create a natural colour contrast. The yellows and reds in the sky reflect in the water and the surrounding snow takes on a blue cast (this is due to the reaction of film emulsion when photographing snow early or late in the day). As well as a contrast in colour, there is a contrast in temperature between the cold snow and the apparent warmth of the sunset, which helps produce a striking image.

Take particular care in summer when exposing for images showing extreme colour contrasts in bright sunshine. For example, in the image of California poppies (see page 100), the brilliant orange is considerably brighter than the polarized blue sky, so a reflected light reading from the flowers would have resulted in underexposure over the whole image. Using a one-degree spot-meter, I instead took the light reading from the sky, because sky acts as a neutral tone, and if it is exposed correctly, then the rest of the scene will also be correct.

On a recent trip to photograph the ancient bristle cone pine trees in the White Mountains of California, I encountered a tremendous difference in exposure range. The altitude there is 3,000–3,500m (10,000–11,000ft), so the sky naturally takes on a deep, saturated blue. The trunks of these weathered trees contain a lot of yellow and, when they are photographed during first or last light, take on a crimson colouring. I wanted to use a yellow/blue polarizing filter (see page 122) to enhance the warmth of the tree and

Tree in a field of rape, Gloucestershire, England
I photographed this scene in a clear, bright light to bring out the bold colours. Putting the emphasis on the blue sky (above) gives the tree more of an impression of isolation and distance because the blue recedes and the yellow advances. With the emphasis on the yellow of the field (opposite), the image has more impact. From a design point of view, having both versions gives the client the choice of putting text over the sky or the field.
Pentax 6 x 7; 135mm lens; polarizing filter; Fuji Velvia

Autumn tree, Vermont, USA
This combination of brilliant orange leaves against a deep blue sky creates a vibrant image. I used a polarizing filter to increase saturation and darken the sky to maximize the effect.
Hasselblad 500C/M; 250mm lens; polarizing filter; Fuji Velvia

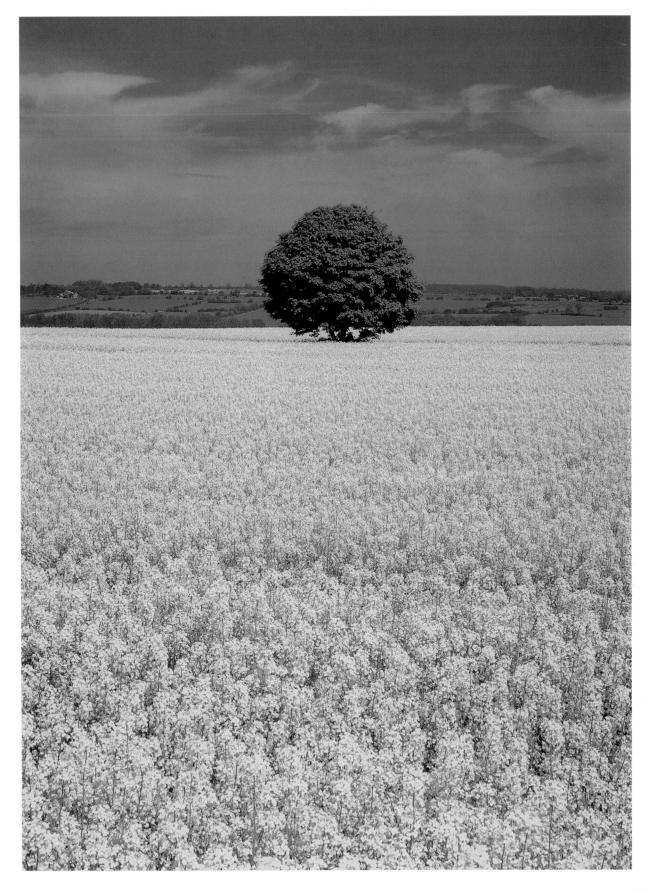

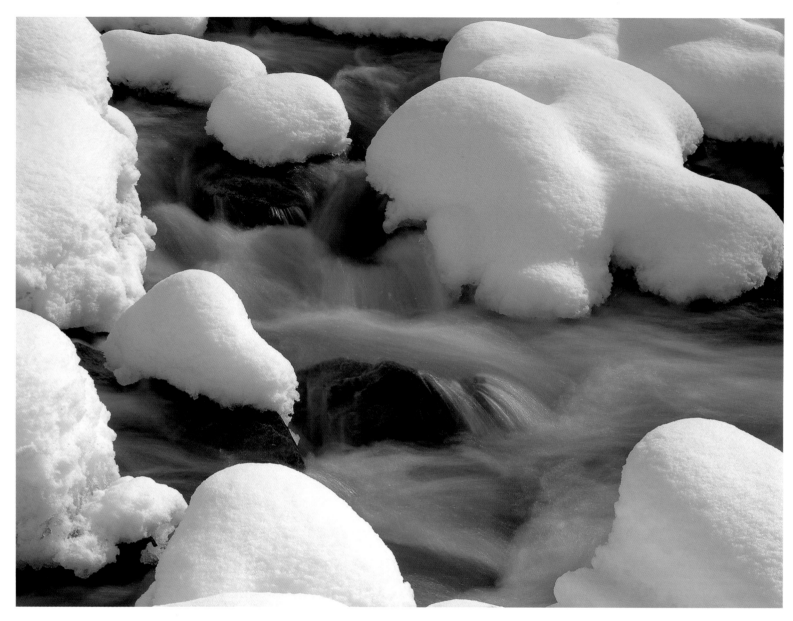

Winter stream of snow-covered rocks

This image could almost be a black and white as the colour is de-saturated and monochromatic. The tonal gradation of the snow tufts are made more apparent by restricting the colour range. I used a slightly long exposure to provide more contrast between the static snow tufts and flowing water. Finally, I neutralized the blue cast that is intrinsic in shadows in snow scenes using an 81A warming filter.
Wista Field 4 x 5; 210mm lens; 81A warming filter; Fuji Velvia

at the same time keep the sky an intense blue, but the exposure range was too great, so I had to take a meter reading from the sky and then bracket several shots either side of this exposure reading.

MUTED COLOURS

In comparison with the vitality of bold, strong colours, muted, or de-saturated shades have a more subtle and calming effect in an image. This is because of their restricted colour range, which you can use to convey many different moods. Whereas bright colours seize the viewer's attention by being shocking, muted colours are more relaxing, evocative and atmospheric. The addition of black, grey or white is what mutes colour. Low-light situations, such as available light indoors or fading evening light, provide

blacks and greys and plenty of dark, shadowy areas. Reflections and flare scatter the light, de-saturating colour and adding white. Shooting into the light also softens colour. Overexposure dilutes colour, giving a bleached effect and creating a high-key image of pale tones and pastels. Underexposure, of course, does the exact opposite, adding black and darker tones to a scene, and providing a low-key effect.

You will find muted colours in most natural landscapes, in grey, urban scenes and in dull, wintry weather. Viewing a distant landscape through rain, mist or fog with a long lens is one way to achieve muted colours as the soft, diffused light created by haze, tones down even the loudest orange or yellow. Haze and mist weaken sunlight by spreading the light and thickening the atmosphere. This softens all hues to a narrower range of pastels. This effect is more pronounced over distance, and in landscape produces delicate tones of pink and orange, which can have a unifying effect on a composition. Fog washes out colour as well, especially at the beginning and end of the day, and as distance increases and the scene disappears into

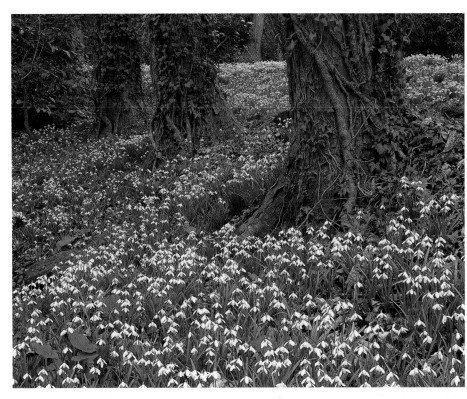

Snowdrops in woodland, Gloucestershire, England
Photographing this wood under overcast conditions helped to maintain the muted colours of brown, green and white.
Wista Field 4 x 5; 210mm lens; 81A warming filter; Fuji Velvia

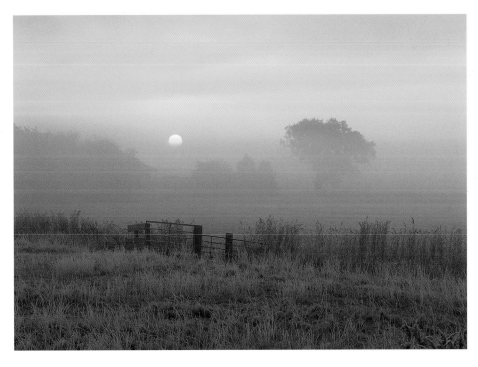

Sunrise over frosty farmland, Norfolk, England
The mist rising over the field softened the light and helped to mute the colours in this image. As the sun rose above the mist the light became stronger, flaring into the lens. I used a telephoto to compress the features.
Pentax 6 x 7; 200mm lens; Fuji Velvia

a shroud of whiteness. In a similar way, dust, smoke and pollution obscure light waves, adding a dusky blue to the light, and a moist winter atmosphere will also produce a blue cast.

You can deliberately mute colour with soft-focus effects, either by using a haze filter or putting a piece of gauze over the lens. Defocusing, or moving the camera with the shutter open, both produce softening effects. Shooting through a dusty window or

La Placita, Tucson, Arizona, USA

The red, yellow and orange colours in this image are harmonious in hue, but choosing a low angle places the colours against a contrasting blue sky, creating visual impact. I used a polarizing filter to remove surface reflections and deepen the blue sky.
Pentax 6 x 7; 200mm lens; polarizing filter; Fuji Velvia

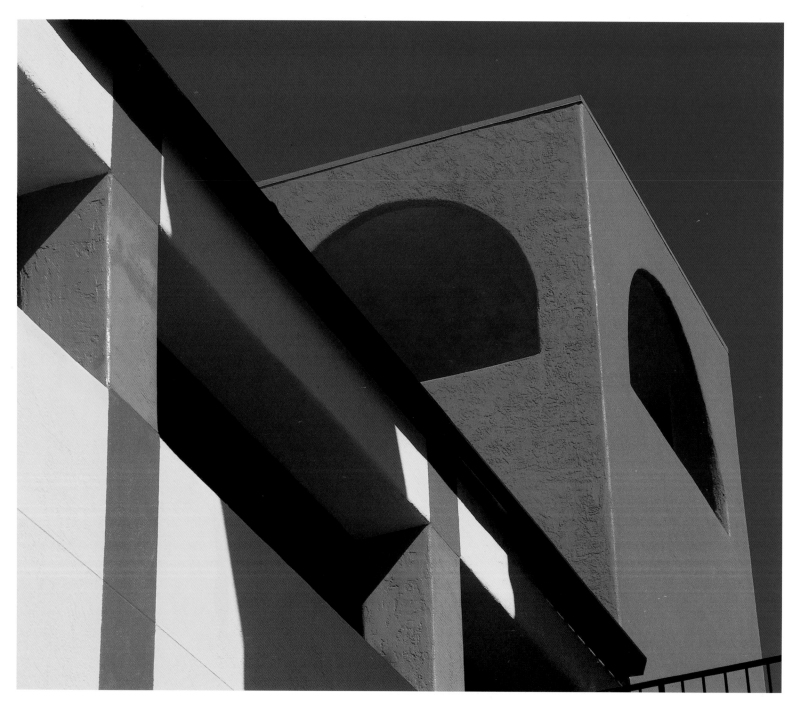

through condensation on glass can create soft and gentle imagery with muted tones.

COLOUR AND FORM IN ARCHITECTURE

Photographs of architecture can either be a realistic impression of an architect's creation or an interpretation of it. Both will show features of the building, but the latter will very likely highlight colour or form. The urban landscape offers an endless choice of subjects; selecting the right shapes and colours to include in the final image of a static structure is a major decision for the photographer. Arranging intriguing lines, shapes, shadows, colours and tones within the viewfinder will establish form in the final image. It won't necessarily be a representation of the complete building, but it may succeed creatively.

Often, because of the space restrictions in which the photographer has to work, it is necessary to change the perspective of the building by using a lens at the extreme end of the focal length. When I photograph architecture I am never trying to record the building, I am trying to create something new – a successful photograph – so I look not at the building as a whole, but its component parts, the way shapes fit together, the way colours are affected by light, and the shade cast by the angles of the building.

I particularly like robust colours in architecture and am always looking for new locations that feature such buildings. Bold colours are paramount in the architecture of Spain, Mexico and the southwestern United States. One factor that each of these locations has in common is strong, bright sunlight, which emphasizes the intense and saturated colours there. Using a polarizing filter in these conditions will remove any surface reflections and further increases colour saturation.

To get the maximum effect from brightly coloured architecture, direct sunlight is necessary as it captures the bold hues in a way that overcast light, with its softening

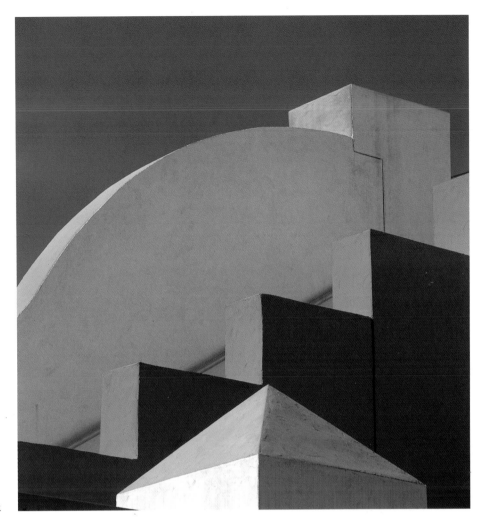

The Mercado, Phoenix, Arizona, USA
The colours in this image harmonize well and give a relaxed feeling. The gentle tones also help to define form. I concentrated on isolating the contrast between the sweeping curve in the top of the frame and the ridged step pattern just below by using a telephoto lens. Hasselblad 500 C/M; 150mm lens; polarizing filter; Fuji Velvia

effect, does not. This is apparent in the image (opposite) of La Placita staircase. Where the light filters through the staircase and hits the wall, the colour is radiant, but the colours of the parts of the wall without the direct sunlight are more subdued. If the sun gets too high in the sky and too strong, however, it can cause excessive contrast, which will bleach colour away. This bleaching is due to the fact that film cannot record an exposure range of more than 5 stops; for more information on how to deal with this by using filters, see page 121.

Buildings that are white or pale-coloured will take on a different colour according to the time of day. An example is the whitewashed mission building in Arizona (left). During the day the light is direct and bright on the white structure. When I photographed it just as the sun was at its lowest in the sky, the white became a pastel shade of salmon-pink.

Mirrored buildings are also a great source of interesting colour and form. Next time you come across a mirrored or glass building, play around with the reflections you can see from various angles and points of view. You can find all sorts of colours and shapes as it reflects the buildings around it and the sky and clouds above. A passing flock of birds or a neon sign from across the street together with the building's own lines can produce an interesting play of colour and form.

San Xavier Mission, Tucson, Arizona, USA

White or light-coloured buildings like this mission are a stark contrast against the deep blue sky when photographed during the day (left, above). But, at either end of the day, the building acts as a blank canvas, taking on the colour of the light shining through the thicker atmosphere (left, below).

Pentax 6 x 7; 75mm shift lens; polarizing filter; Fuji Velvia

COLOUR IN ABSTRACT AND NATURAL FORMS

Making an abstract image by photographing the world around us relies entirely on the arrangement of colour and form. They are the components with which we have to construct an image. As a photographer, your goal with this kind of image is much more like that of a painter: you are trying to create an image that has impact on the viewer by the way it is constructed. You cannot rely on the

La Placita staircase, Tucson, Arizona USA

The vibrant colours of this business complex almost went unnoticed while I was photographing buildings in downtown Tucson. When I saw a small flash of red I went to investigate further and found this incredible myriad of intense colours and shapes. The light shining through this staircase introduced strong diagonal lines that paralleled the railing and stairs, creating unusual form in the image. Positioning the camera was crucial. When I viewed the scene a few steps to the left, I could see down the staircase to conflicting elements that detracted from the image. I eventually chose this angle because of the diagonal shapes, and the blue and purple wall, which helped to create the triangular glimpse of the stairs and hold the picture together.

Pentax 6 x 7; 75mm shift lens; Fuji Velvia

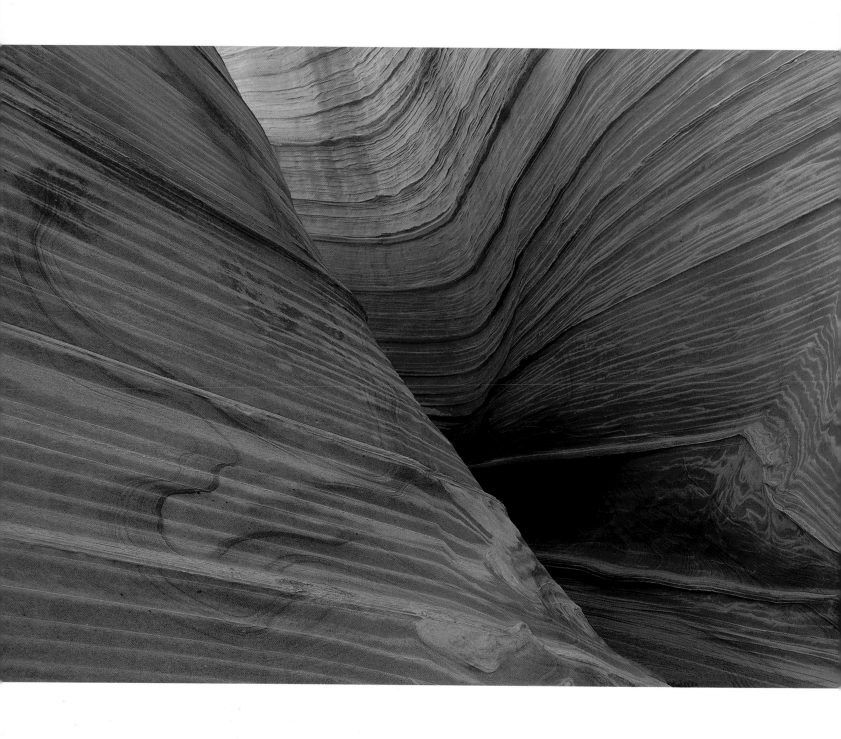

Sandstone wall design, Paria Wilderness Area, Arizona, USA

The sandstone striations on this wall are great examples of natural form and design. I initially viewed this image with my 4 x 5 camera, but felt that the lines on the left and right of the frame in the panoramic format helped to pull the composition together considerably. The soft, reflected light was ideal for bringing out the colour and form instead of direct, contrasty light.

Fuji GX617 panoramic; 180mm lens; Fuji Velvia

Inside a hot-air balloon, Albuquerque, New Mexico, USA
Looking at objects from different angles often opens opportunities for unusual images. When I was photographing the International Balloon Festival I made a list of every possible angle from which I could photograph a balloon. Photographing from the inside of the balloon was one consideration, but finding an appropriate canopy with the right design proved more difficult. After looking at over 200 balloons, I discarded the novelty balloons and those with mundane colour designs. I was lucky to find this one still lying on the ground preparing to go up.
Pentax 6 x 7; 45mm lens; Fuji Velvia

spectacle of a great natural feature or a wonderful building to give you the 'wow' factor, as it will not necessarily be clear what the photograph is of. However, you do have the advantage of getting a good reaction when you reveal the subject. The picture on this page is a good example: it is not clear at first glance that it is even a photograph, as all attention is focused on the shapes and vivid colours.

Extraordinary and beautiful colour combinations and patterns occur everywhere you look in nature, and making 'abstract' images of them draws attention to

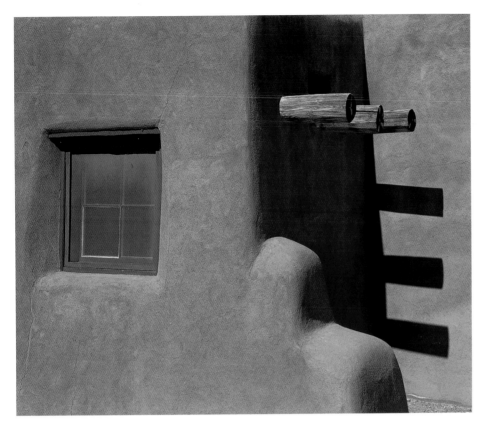

Adobe abstract, New Mexico, USA

The burnt sienna colour of the adobe-style building works beautifully as a dynamic single colour. I walked around the building to check out what interesting shapes the shadows were creating. After trying several different compositions, I opted for this one as it gave the best feeling of balance.

Pentax 6 x 7; 135mm macro lens; Fuji Velvia

Aerial view of sand dunes, Namibia

I wanted to capture the form and sensuous curves of the giant sand dunes in Namibia, so I opted for a different perspective and photographed them from the air. One problem I encountered was that when an interesting shape was spotted, I had to compose and shoot quickly. There was little time to think about adjusting the composition because of the speed of the plane. And trying to backtrack to find the same shape in a sea of dunes was pretty much impossible. One nice aspect is that every shot is unique. Shooting just after sunrise enhanced the already deep orange dunes and presented perfect contrast to reveal the natural form.

Pentax 6 x 7, 75mm shift lens; pushed 1 stop; Fuji Velvia

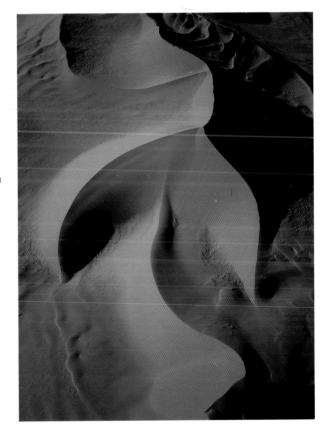

the amazing formations that context so often causes us to ignore. The photograph of the sandstone canyon in Arizona on pages 110–11 forces us (once we realize what it is) to marvel at the sweeping contours, and subtle colours, patterns and texture of the rock. Photographing the desert from above (right) similarly throws attention on to the shape and form of the dunes rather than the vastness, heat and solitude of the desert, which a traditional composition is likely to express.

The image above, however, proves that although the world is full of natural subjects, the image is ultimately created by the photographer. The composition is arranged here in terms of shapes and blocks of colour or tone. One of the key 'forms' in this composition is the dark shadow of the three wooden beams on the the wall of the house. Within the two-dimensional picture area the three dark shadows have as much 'form' as the real wooden beams, or the wall of the adobe house; they are simply another component in the composition, no more or less important than the physically solid elements.

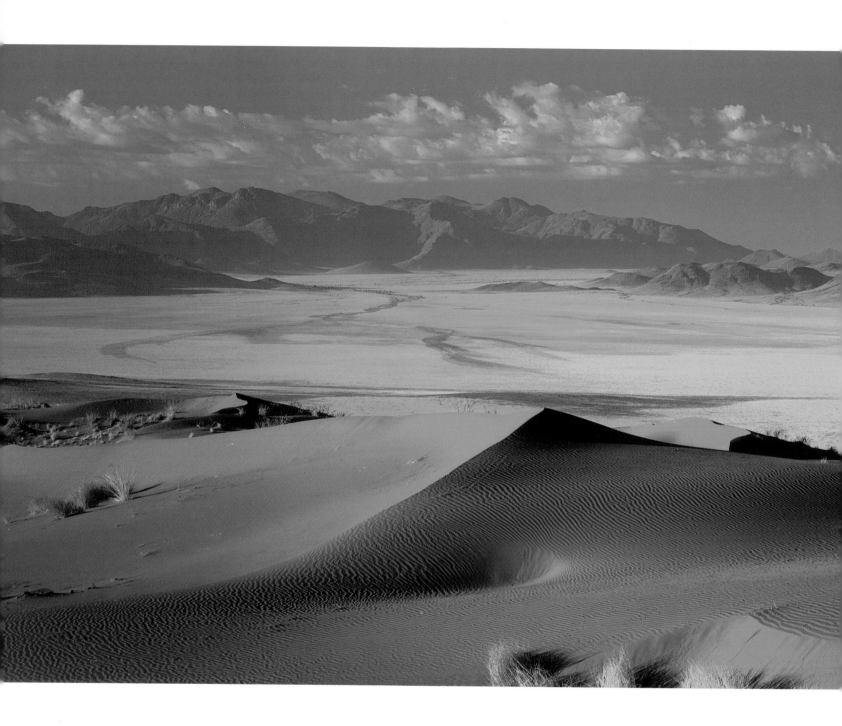

enhancing the image

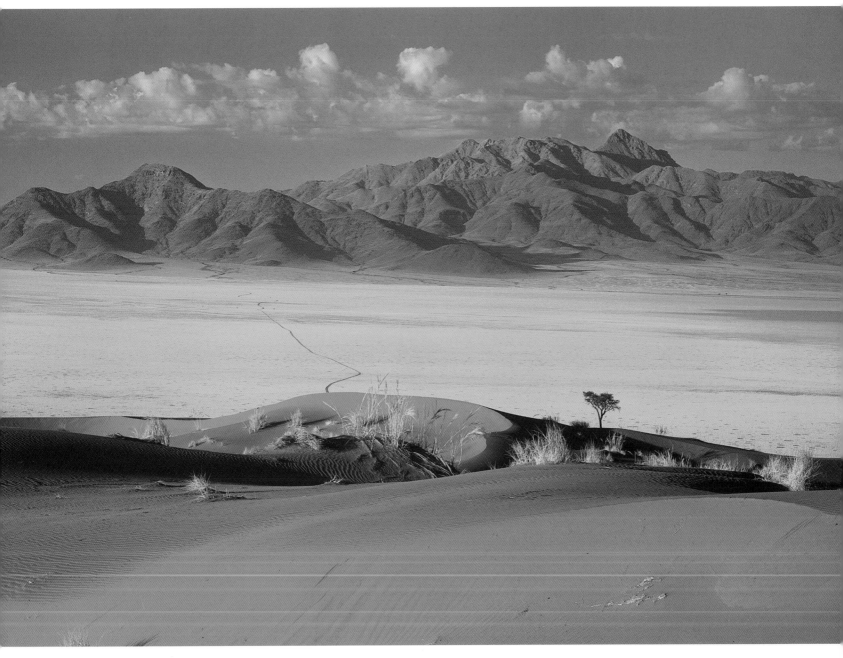

Namib Rand, Namibia

The sand dunes in Namibia naturally have a deep orange colour, but I wanted to increase the colour contrast between the sand and the blue sky to give the image more punch. I achieved this by using a Cokin yellow/blue polarizer. The beauty of this polarizer is that it maintains the blue sky while increasing the warmth in the sand dunes.
Fuji GX617 panoramic; 180mm lens; yellow/blue polarizing filter; Fuji Velvia

There are three major ways in which you can change an image and improve its impact: through the use of filters, by the length of exposure, and with digital manipulation. Perhaps the easiest and most common of these methods is by using filters. When used selectively, filters can greatly improve the final result, but the key to success is to use a filter without the viewer being able to tell from the final image. There are several types of filter that are particularly useful, such as warming, neutral-density graduated and polarizing filters. Some other, more gimmicky filters can overshadow the content of the image, and completely dominate the whole shot.

This principle of intervening to improve an image in a way that is not apparent to the viewer holds true for all methods of enhancing a photograph: except in very unusual circumstances (like the last photograph in this chapter), I use only methods that will achieve the desired result without it being obvious. It is a question of enhancement combined with discretion.

Giant's Causeway, County Antrim, Northern Ireland
I had seen so many good images of the Giant's Causeway, but when I turned up one summer's evening it started to rain and I had to photograph in very poor conditions. I decided to counterbalance the cold colour cast with a sunset filter, and used a neutral-density graduated filter over the sky to keep it from washing out. The sunset filter put some nice colour into the sky while taking the blue out of the basalt rock in the foreground. The light was rapidly disappearing, making my exposure times very long – about 2 minutes. Because the clouds were moving swiftly, the long exposure gave them a wispy look. I was pleasantly surprised when the results came back from the lab.
Wista Field 4 x 5; 90mm lens; sunset filter, 0.9 neutral-density graduated filter; Fuji Velvia

WARMING FILTERS

One of the quickest ways to add impact to a photograph is with a warming filter. Warm colouration in a picture is much more inviting than a cold cast as it gives the viewer a feeling of well-being. Warming filters come in varying degrees of colour and density, so they can be used for effects from the subtle to the dramatic. The 81 series of warming filters starts with the 81A and goes through to 81EF, increasing in density. I find the most useful in the series are the 81A and the 81EF. I use the 81A to counteract the cold colour cast created on film when shooting snow scenes or in overcast, shaded conditions. When you look at a scene through the viewfinder with and without the filter, the scene will show only a very slight difference, but it is enough to make a considerable effect on the film. The denser 81EF adds a stronger overall warm cast for scenes shot at either sunrise or sunset, or it can just add atmosphere when needed.

Windmills at Kinderdijk, Holland

I wanted a strong colour to contrast with the repetitive silhouettes of the windmills. The colour in the morning sky didn't have enough depth, so I used the bottom half of a sunset filter over the lens.
Pentax 6 x 7; 135mm lens; sunset filter; Fuji Velvia

The Lee coral, coral graduated and coral strip filters are also important in my arsenal of filters. I use the coral filter to warm up dawn and dusk scenes, such as the image from Tuscany (right, below). It is also useful for enhancing autumnal colours. The coral graduated filter can be used to bring out additional colours in the sky when you don't want to change the colour in the foreground of the picture. Alternatively, use this filter upside down so that the coral colouring livens up foreground elements, such as a bed of reeds. The coral strip filter is perfect for improving the colours of a sunset or sunrise when you want to retain a smooth gradation to deep blue in the sky without affecting the foreground. This is particularly ideal when you are photographing a body of water such as a lake and you don't want to compromise the overall colour. By positioning the strip at the horizon, you will add to the afterglow of colour, yet maintain the blue in the sky and its reflection.

Sunset filters usually come in two different degrees of intensity – light and heavy. They are graduated, with a deeper warming colour towards the top of the filters. I get more use out of the light sunset filter as it enhances the scene, whereas the heavy, darker filtration can be over-powering. I don't use the sunset filters just for sunsets and sunrises; they are useful for woodland scenes in autumn where the darker part of the filter enhances the golden hues of trees, while the lighter part of the filter removes cool blue casts from the rest of the scene. I have even found that using the light sunset filter in winter conditions, such as a snow scene with clouds towards the beginning or end

Morning mist around Belvedere, San Quirico, Tuscany, Italy
These two images show the difference between a straight shot and one that is warmed up with a coral filter. The straight image (right, above) has a very cold feeling, with a blue colour cast. The coral filter transforms the image to give a feeling of warmth (right, below). Fuji GX617 panoramic; 180mm lens; coral filter; Fuji Velvia

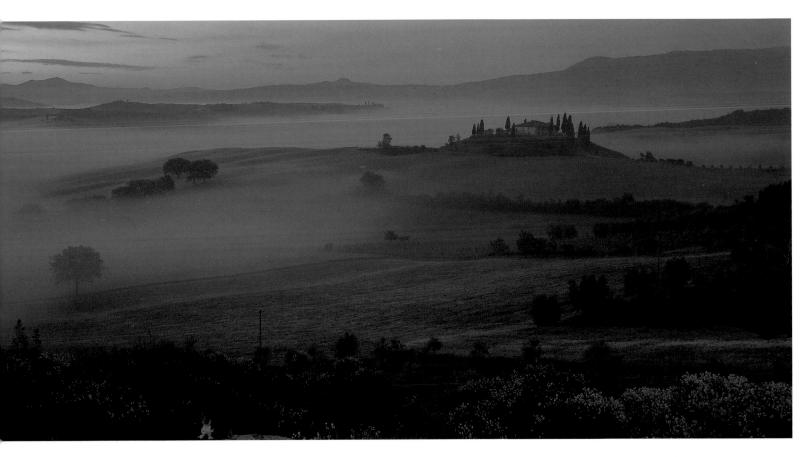

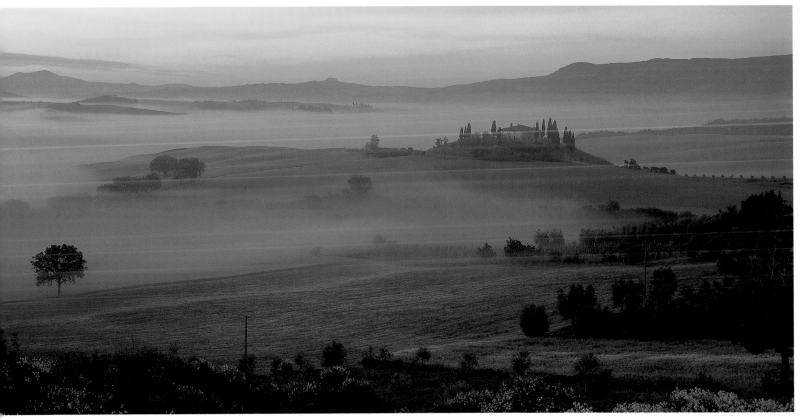

of the day, is effective in neutralizing the blue in the snow, making it look more of a true white. It also enhances colour from the low angle of the sun on the clouds.

NEUTRAL-DENSITY GRADUATED FILTERS

Neutral-density (ND) filters reduce the intensity of the light reaching the film without affecting the colour balance. A non-graduated filter can be used if you want a longer exposure over the whole image. Much more useful is the neutral-density graduated filter (ND grad), essential in any photographer's bag because it can control the difference in the exposure range of a scene that film is otherwise incapable of recording without giving colour distortion. The latitude range of transparency film is about 5 stops. When the exposure range within a scene extends beyond this, you will lose detail in either the highlights or the shadows. By exposing for the foreground and placing a ND grad filter

Lake Carezza and Dolomites, Italy

This is a classic example showing the benefits of a neutral-density graduated filter. The exposure range of the scene far exceeds that of the latitude of the film. In the first picture (far left), I exposed for the reflection in the lake, but the detail in the mountains and sky is severely burnt out. In the second picture (left), I used a 0.9 hard grad down as far as the tree line to compensate for the difference in exposure.
Fuji GSW 6 x 9; 65mm lens; 0.9 neutral-density hard graduated filter; Fuji Velvia

over the sky, you reduce the exposure range so that it can be recorded by the film. (This filter should not be confused with a grey graduated filter, which I have found can change the colour balance, giving anything from a green to a magenta cast to skies.)

These filters come in nine increasing degrees of density in third-stop increments, beginning with 0.1 (⅓ stop) up to 0.9 (3 stops). You can choose to have the gradation transition either hard-edged or soft. I find the soft better for uneven horizons containing elements such as trees or mountains where just the intensity of the sky needs to be reduced. And I get the most use out of the 2-stop and 3-stop filters (0.6 and 0.9). The 1-stop filter (0.3) can also be useful, and you can double up, using the 0.9 and the 0.3, for instance, to make a 4-stop difference. On an overcast day when the sky has texture, even though the contrast range is lower, you will still need the ND grad to retain the texture in the sky together with the detail in the foreground. On days with storm clouds, this filter will increase their threatening and dramatic qualities.

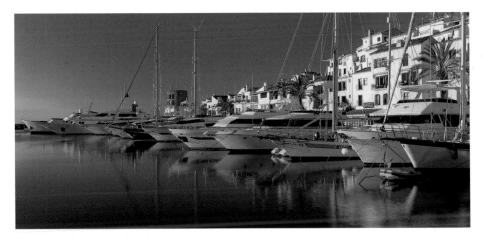

Puerto Banus, Marbella, Spain
The Cokin 173 yellow/blue polarizing filter was ideal for enhancing the morning light on the yachts and buildings in this harbour (above), which can be compared with the image taken without the filter (below). When used in the right instance, this filter can produce striking results, without looking too obvious.
Fuji GX617 panoramic; 90mm lens; yellow/blue polarizing filter; Fuji Velvia

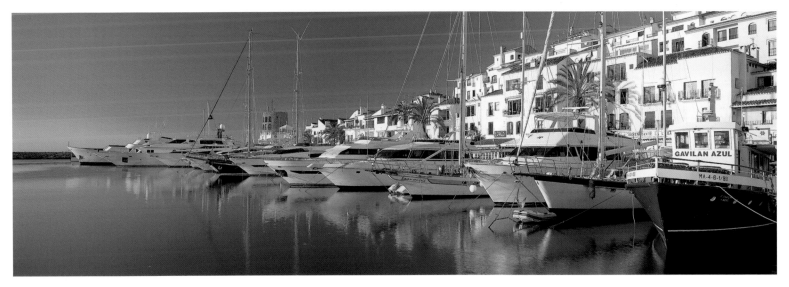

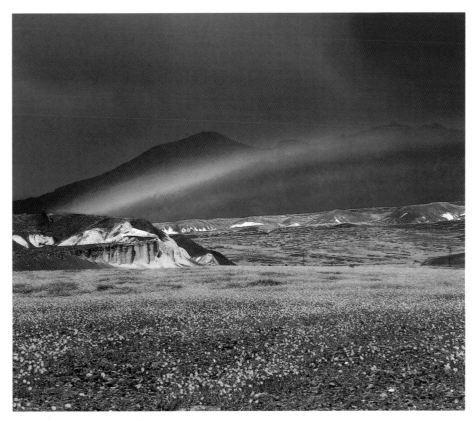

Rainbow over desert sunflowers, Death Valley National Park, California, USA

Photographing a rainbow normally amounts to a great deal of scrambling around at lightning speed to capture it before it disappears. In this case, during the time it took me to photograph it on two different formats and several rolls of film, it was still there just as strong as when it first appeared. The mountains behind probably helped to hold the band of rain in one place. This allowed me time to experiment with different filters. I found that the polarizer saturated the colours of the flowers and rainbow to its maximum potential. Pentax 6 x 7; 75mm shift lens; polarizing filter; Fuji Velvia

POLARIZING FILTERS

If I had to choose just one filter to consistently add real impact to my images, it would be a polarizer. I consider it essential. Each of my lenses has one permanently fitted to save time: it is easier to remove it when it is not needed than to fit one in a hurry. A polarizer is so useful because it not only reduces unwanted reflections and glare from surfaces such as glass or water, but it increases the saturation of blue skies. By slightly deepening and enriching the blue of the sky, the clouds stand out better against it. The degree of polarization can be seen by simply rotating the filter, and the maximum effect is achieved at a 90-degree angle to the sun, when reflections can be seen to vanish.

Situations in which a polarizer can be most useful are when photographing reflective buildings or colourful subjects with reflective surfaces. It will also cut haze in distant landscapes. When photographing a still body of water, such as a lake or pond, rotating the polarizer will remove the reflections from the water, allowing you to see objects under the surface. As rainbows are primarily made up of polarized light, rotating the polarizer will saturate the colours by removing reflections from the moisture in the air. (If you rotate it too far you will remove the rainbow altogether.) One side-effect of a polarizer is that it may enhance the colour of sky unevenly, especially with a wide-angle lens. This can be corrected afterwards digitally (see page 136), but is something to be aware of.

Another polarizer that is particularly good for enhancing certain colours is the Cokin 173 yellow/blue. I use it to enhance a warm foreground and blue sky and, like a normal polarizer, its effect depends on the rotation of the filter. When it is turned to orientate the yellow or blue to the position that suits the scene, the polarized areas will take on either the yellow or the blue of the filter (see the image of Puerto Banus, page 121). When I want to add warmth to my subject, for instance, the yellow/blue polarizer manages to add just to the subject, retaining the blue sky, unlike the warm-up filters, which can make blue skies look muddy. As I enjoy photographing deserts, the yellow/blue polarizer makes such images come alive. It's not a filter that can be used in most situations, but with a little experimenting you will find out when it works best for you. Most polarizers have a 2-stop reduction in light; the yellow/blue has a 2½-stop reduction. Other (less useful) bicolour polarizers available are red/blue, purple/orange, blue/orange and red/green.

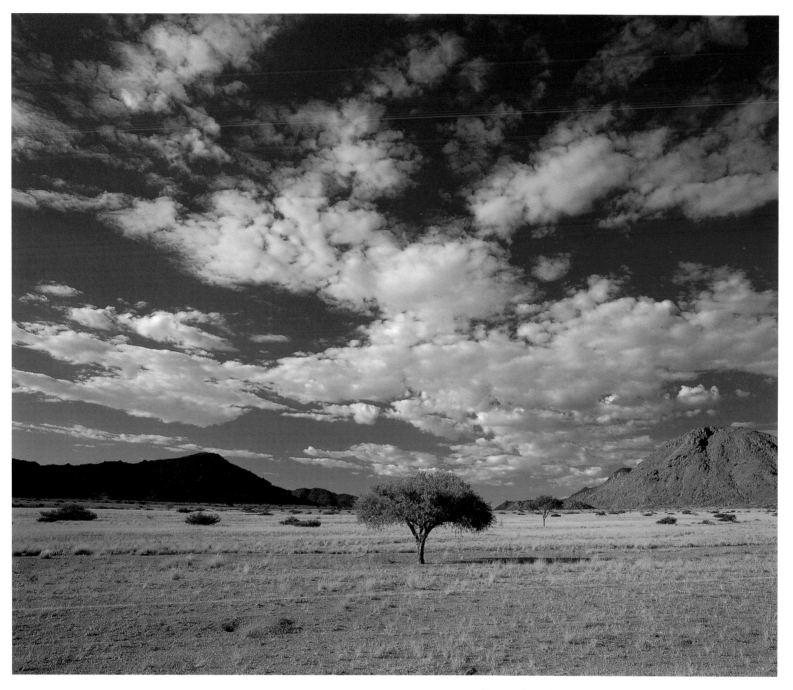

Tree and sky, Namib Desert, Namibia

I spotted this mushroom-shaped tree in the middle of the Namib Desert and thought it would make a good subject, especially as the sky had some interesting cloud formations. I walked around the tree to decide which angle would provide me with the best composition along with the maximum polarization of the sky. I positioned the tree in the middle of the frame between the two mountains. The polarizer gave great separation between the clouds by darkening the sky.

Pentax 6 x 7; 45mm lens; polarizing filter; Fuji Velvia

Coastline at Dunstanburgh Castle, Northumberland, England

I wanted to create an atmospheric image of the castle with the rugged coastline in the foreground, so I arrived just before sunset. The tide was at just the right level to capture the waves washing over the rocks during the long exposure. If the tide had been out further it wouldn't have worked. As the waves rush in and cascade through the rocks, during a long exposure (20 seconds at f/32) they take on a misty appearance. There was a little colour in the sky, but I decided to enhance it more by using a coral filter.

Wista Field 4 x 5; 210mm lens; coral graduated filter; Fuji Velvia

EXPOSURE

Another effective way of enhancing an image is through the use of long exposures, which, when used both day and night, can add drama. Long exposures can express motion, heightening mystery and adding atmosphere or excitement.

A subject that I love to photograph, and which lends itself to exposure manipulation, is water. Whether it is waterfalls, rushing streams or waves at the seaside, these subjects respond well to using a long exposure, creating silky cascades from waterfalls and misty effects along coastlines. To accomplish this effect you need two vital components: a sturdy tripod and the right amount of water. I use a tripod as a matter of course because it slows me down and makes me pay more attention to the elements of the composition within my frame. When you hand-hold the camera, it is only too easy to miss an element that breaks the edge of the frame. All the pictures in this book apart from the one taken from

Sandy Mouth Bay, Cornwall, England
The graphic shapes of the rocks are a nice contrast between the dusky pink sky and the blue water. I positioned the tripod just beyond the water's edge so I would have a diagonal line of small rocks with enough water around them to emphasize the gentle flow of the waves. The great thing about using a long exposure (20 seconds at f/22) while the waves are flowing in and out is that you never know exactly how the final result will look.
Wista Field 4 x 5; 90mm lens; Fuji Velvia

Arc de Triomphe, Paris, France

This classic image of the Arc de Triomphe benefits from using the light streaks from the car lights to add colour and lead the eye to the monument. I based my exposure (45 seconds) on having the sky 1-stop brighter than the monument and choosing an aperture (f/22) that would allow enough traffic to move through the scene to record their lights. Because the traffic frequently stopped for the traffic lights, I would carefully cover the lens with my hand and remove it when the cars started moving again, otherwise their images would record. Likewise, when a bus approached I would cover the lens so the lights on the top of the bus didn't make an inconsistent light streak that would have gone through the trees and the monument.

Fuji GSW 6 x 9; 65mm lens; Fuji Velvia

a plane (page 113) have been taken using a tripod. As for the quantity of water, when there is not enough the flow is not as impressive, and if there is too much, the highlights on the water's surface become overwhelming, causing distracting masses of white water. Get it just right, and you will be able to see texture in the flowing water.

When photographing coastlines you might want to check the tide times to see when the water will be at the right height to reach any rocks in the foreground. I find that an ebb tide makes it easier to photograph along a coastline as, when the water is flowing out to sea, I don't have to keep moving the camera to avoid getting engulfed by the waves. The length of exposure with water is governed by the situation and how much the water is moving. When using this technique for coastlines, I like to include several passes of incoming waves. In the case of a waterfall or stream, the length of exposure is dependent on the amount and flow of the water. Overexposing will result in the water looking too bright in the final image; it is often best to bracket to be sure of the right result.

Cityscapes at night have all the elements needed for a long-exposure image. The white and red streaks made by vehicle headlights and tail lights along the streets of a city bring images to life by adding colour in dynamic lines that create depth and lead the eye towards points of interest. Photographing buildings or monuments at dusk with traffic moving through the scene gives liveliness to the whole that daytime shots might not provide.

I prefer to photograph these urban scenes about 10 to 20 minutes after sunset, when there is a 1-stop difference between the sky and the buildings, giving a good visual separation between the two. With the light levels low at this time of night, the exposures will naturally be longer, but you will need an exposure of at least several seconds in any case so that you can capture enough cars moving through the scene.

Torc Waterfall, County Kerry, Ireland
The shape of this waterfall was ideal for a vertical panoramic image. The line of the upper falls cascading down to the lower falls balances the two halves of the image. An exposure of 15 seconds at f/32 gave sufficient depth of field with the 180mm lens and created the silky-looking water. Fuji GX617 panoramic; 180mm lens; Fuji Velvia

THE DIGITAL REVOLUTION

Digital technology has affected almost every aspect of photography. Ways of enhancing traditionally taken photographs using digital technology are covered on the following pages, but initially I'd like to put digital technology into some context as it relates to my work. The first thing to say is that I don't use digital cameras at all. Perhaps in time I will but for the moment I prefer to take photographs traditionally. Where digital technology is useful to me is in manipulating images. Shooting digitally is not without its attractions, however, one of the major advantages being a considerable saving in film and processing costs. Equally, there is no need to store film in refrigerated conditions, to carry bulky film around on photo shoots, or to worry about the effects of airport x-rays on film. There is less weight of camera equipment, depending on the storage device (laptops can be heavier and bulkier than digital wallets), and you have more control over the image. As you can instantly see whether you have captured what you intended by viewing the playback, it makes waiting for film to come back from the lab seem rather tedious in comparison.

Some of the disadvantages of working digitally are in keeping up with the changing technology of camera equipment. Once you have decided on a camera it soon becomes outdated with faster, higher-quality image-capturing devices that are only too tempting to buy. With this complexity come more things that can go wrong, and technical failure in the field is a concern. For example, the CCD chip in a digital camera is electronically charged and therefore tends to attract dust to your image, so after the image capture, computer adjustments need to be made to all the pictures. Safe storage of digital images is still something of an unknown as the life of a CD is not infinite.

The Internet is a powerful tool when it comes to marketing images. The versatility and advantages of having images on the Internet to show to the rest of the world are obvious for any professional photographer. My business has been helped in many ways by clients being able conveniently and swiftly to view images on my website. Foreign clients can quickly do a selection from the website as a result of a specific request without the expense, time and customs hassles that accompany sending a batch of transparencies overseas. This also eliminates the possibility of original transparencies getting lost, damaged or kept for long periods.

Working traditionally, when I get the film back from the lab, I edit the shots and send them out to clients. Many clients still insist on viewing 4 x 5 transparencies on a lightbox

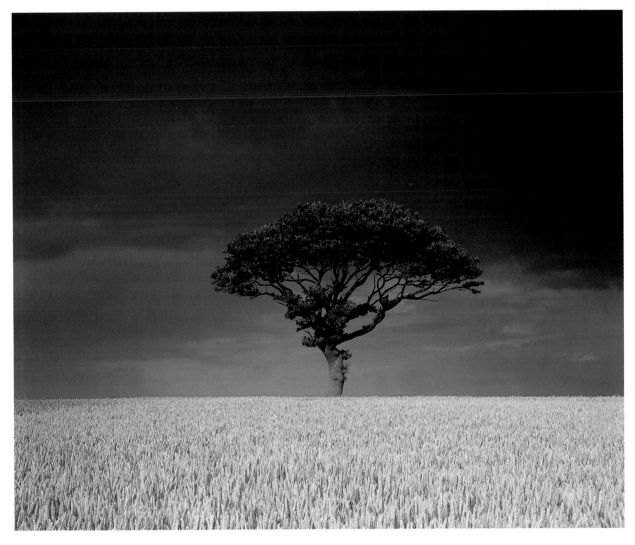

Tree in a wheat field, Norfolk, England

I purposely broke the rule of thirds and put the tree in the centre of the frame to give it more attention. To accomplish the image, I set up the camera and waited about an hour until the sun came out to light the scene as a passing storm moved behind the tree. I later digitally removed the small trees either side of it (far left) to strengthen the composition, which now has no distractions. Wista 4 x 5 field; 150mm lens; 0.6 neutral-density soft graduated filter; Fuji Velvia

and, in seeing them in this way, the quality is much better. Despite the convenience of websites, the image quality of their thumbnail-sized images cannot be compared with the impact and resolution of a saturated 4 x 5 transparency on a lightbox. It is also much quicker to place an image on a lightbox than to fire up a computer and insert a CD.

Quality is my main concern, and the quality of digitally produced images is at the moment somewhere between 35mm and medium format, and it will be a while before it reaches the quality of a 4 x 5 image. I could use a 4 x 5 digital camera back, but this is not the most convenient way of shooting landscapes, and I can buy an awful lot of film for the cost of a digital camera back.

ADDING ELEMENTS DIGITALLY

An original image can be enhanced dramatically by adding elements digitally. There are many good reasons for doing this, the main one for me being that you can make an image more commercial. My business is licensing the rights to stock images, so saleability is important. The image of Lake Buttermere (see page 131) has many new possibilities with the addition of the canoeist. Now it is not just a dramatic landscape that might appeal to calendar manufacturers, it is a lifestyle image about the great outdoors and active pursuits. It might also appeal to outdoor equipment makers, to corporate brochure compilers, and to those designing display prints and CD covers.

Full moon over sand dune, California, USA

I hiked out into these dunes before sunrise to capture them at first light. This was one of the results, actually one of the mistakes from the morning shoot. I grossly under-exposed a couple of sheets of film – those early morning rises tend to cloud my mind at times. As there was still plenty of detail in the sand, adjusting the density and contrast salvaged the image. This looked much better, but it still needed something else to set it off. I had a shot of a moon that sat nicely in the dip of the dunes. What would have ended up in the dustbin, is now making money as a stock image.

Wista Field 4 x 5; 90mm lens; polarizing filter; Fuji Velvia

Many people consider manipulating photographs to be cheating, but manipulation has been going on in photography since it began – it is just much easier to do now, and, on the whole, much more convincing. When the wildlife and landscape photographer Art Wolfe brought out his book called *Migrations*, on the cover it had an image of zebras, which had an added digital zebra to fill a gap in the herd in order to improve the composition of patterns. This was criticized. But as the book was an artistic view of migrating animals, not a true natural history portrayal of them, I see nothing wrong with using digital addition in this way. Photography has always been the photographer's interpretation of what he sees.

There are always several ways to carry out any technique with photo manipulation software. No one way is necessarily the correct way. You need to choose what is easiest for you and accomplishes the best result. Whatever way you choose to manipulate your image, one rule should always be observed: never work on the original file. Make a duplicate so if you encounter any problems you can always revert back to the original. There are many manipulation programs available, but as Adobe Photoshop has become the industry standard, this is what I choose to use. It is an incredibly powerful program, which can enable you to carry out the easiest or the more difficult tasks.

Some compositions can be improved immensely by adding elements that not only help the structure, but also the atmosphere and, as a result, the overall impact. Cityscapes and landscapes shot towards dusk can often benefit from the addition of a well-placed moon. The advantages of this are that you can choose not only exactly where to place it in the composition, but also which phase of the moon – full, half or crescent – best suits the image. I usually double-expose the moon on the same piece of film when shooting in the field and have a collection of

Lake Buttermere, Cumbria, England

This image of Lake Buttermere (right) had been selling well for years in calendars and brochures, but because it had made its rounds through all of the calendar companies in the UK, the sales had begun to taper off. A local digital studio wanted to show off its services by including a canoeist on the lake (above). Adding a human element has greatly increased the sales potential of the image.

Original image (right): Wista Field 4 x 5; 90mm lens; polarizing filter; Fuji 50D. Digital output on Fuji Velvia 120.

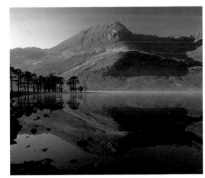

moons in different phases to choose from to add later if no moon is present.

When you add one or more elements to an image, you need to consider the lighting of each. Make sure there is consistency of direction and colour of light; otherwise the effect is more than unsettling. Another factor to think about is the film stocks that you are combining. If you start with an image shot on a fine-grain film, such as Velvia, it is not a good idea to add an element shot on high-speed film. The grain structure will not match and the difference will be obvious to the eye, making the

Boat and cloud reflections, near Southwold, Suffolk, England

I shot this scene early one morning, knowing that I would have to eliminate some distractions that weakened the effect I was after. The first things to go were the power lines that ran across the horizon. There were several buoys floating in the water, which detracted from the boat. Worst of all was the outboard engine on the boat – modern machinery just didn't go with the peaceful feeling of the scene.
Wista Field 4 x 5; 90mm lens; polarizing filter; Fuji Velvia

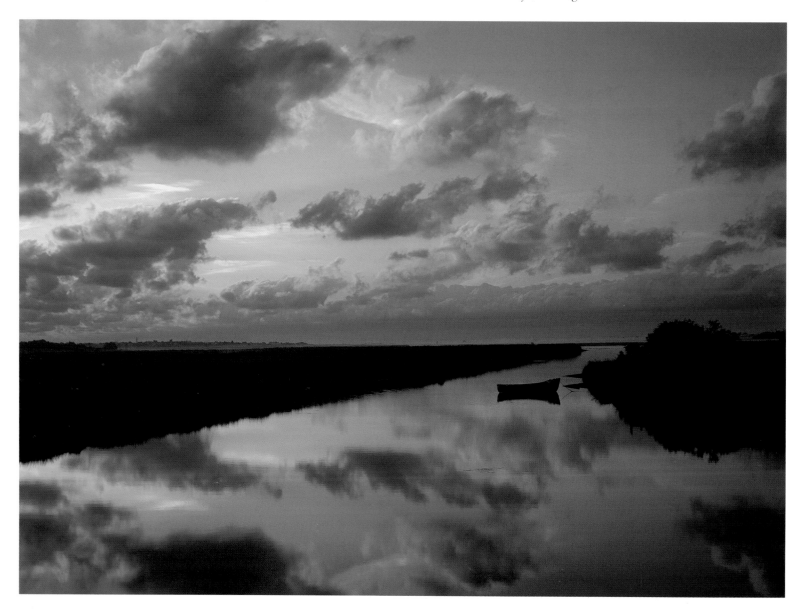

Sand dune and tree, Namib Desert, Namibia

The original image (right, above) needed some minor adjustments to the colour of the sky and the density of the shadow side of the dune. I thought the blue needed to be shifted slightly to contrast more with the orange dune and I didn't want to have any detail in the shadow of the dune, because I was after more of a stark contrast. So I began by selecting the shadow of the dune and adjusting the density in levels. Then I selected the sky and adjusted the colour using curves in a new adjustment layer. Finally, I removed all the other dead trees that distracted from the single tree (right, below).
Pentax 6 x 7; 200mm lens; yellow/blue polarizing filter; 2x tele-converter; Fuji Velvia

whole image unconvincing. Make sure also that the perspectives of all the images are consistent; for example, if one element has been shot with a wide-angle lens complete with distortion, and you add another element that has been shot with a telephoto lens with flattened perspective, the two simply will not work when combined.

A most useful aspect of digital manipulation is being able to remove unwanted elements from an image. In fact, just being able to do basic retouching of dust specks and pinhole marks that occasionally find their way onto my sheet film is a bonus, as this film would otherwise be rejected. On many occasions I have not taken pictures because of power lines, jet plane condensation trails, cars, people, scaffolding or the many other items that cannot be manually removed, and this can be very frustrating. Therefore, digital removal is a helpful tool, but I don't want to rely on it to the point of becoming lazy. I make sure I use it only when there is no other way of removing the intrusion myself when making the picture.

A major reason to remove something from an image would be to strengthen the composition. For example, the oak tree in a wheat field (see page 129) had small trees on either side of it, which I felt detracted from the overall impact of the image. I wanted the viewer's eye to go straight to the oak without any other distractions in the picture. In the shot of the red heliconia against a black background (see page 58), I removed a distracting branch from behind the plant and performed digital cosmetic touch-ups to slight imperfections in the plant that lessened its impact.

CORRECTING COLOUR

At an exhibition of my work recently I was asked if the vibrant and saturated colours had been digitally produced. The answer is, of course, no. I cannot claim that my photographs have never been near a computer, nor that I do not use the technology occasionally to make the most of them, but essentially the secrets of the saturated colours in my images are polarizing filters, Fuji Velvia film and shooting at the right time of day. If necessary, however, colour correction is quickly accomplished with the computer.

An overall colour cast, such as an image shot in fluo-rescent or mixed lighting can be easily adjusted. When you want to selectively alter colours within a scene, the computer gives a surprising amount of control; this process could not, of course, be done as easily in the traditional darkroom. I can select parts of a scene and alter the colour without affecting the rest of the scene.

It is important when correcting colour to ensure that the calibration between monitor, scanner and printer is correct, as each of these variables is capable of producing quite different colours to the original. Check that the results on each are identical.

A STEP FURTHER – CHANGING A SKY

Perhaps it is a step beyond 'enhancement', but being able to change a sky is one of the most useful manipulation techniques in my work. Often situations occur where the existing sky is just not as dramatic as I might like, so re-placing the original sky with one that I have already taken can really improve a potentially good image. I photographed this elk (right, above) in Jasper, Canada one afternoon. As he stopped at the top of an embank-ment I had enough time to make only three exposures, with the last one being the best silhouette, before he walked away. The sky was fairly mundane, and I thought of an image of a sky at sunrise that I had taken a few years earlier that would be perfect as a replacement.

Combining these two images, I first made adjustments to the colour balance, saturation and brightness of the dramatic sky as it was originally too overpowering for my liking. Copying the two images into the same file as different layers, I selected and deleted the sky from the photograph of the elk, being careful to make sure that all the detail in the outline of the grass was retained. This now allowed me to see the new sky with the silhouette of the elk. I then combined the two layers for the final picture.

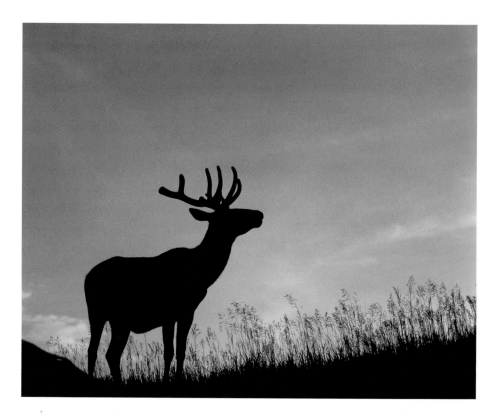

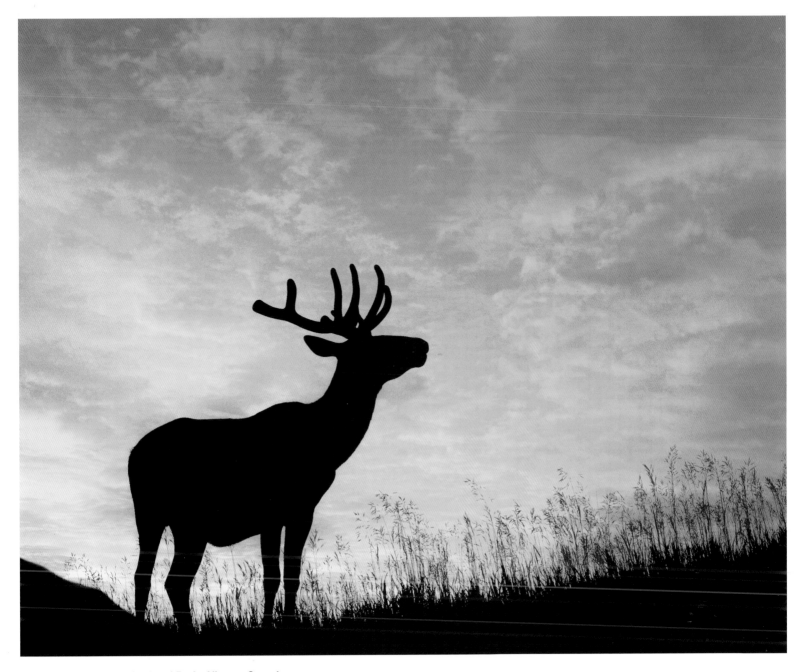

Elk at sunrise, Jasper National Park, Alberta, Canada

When I photographed this elk silhouetted against the sky (opposite, above), I knew I would have to change it to make it a more powerful image. I remembered a sunrise that I had photographed a few years earlier in the Peak District (opposite, below) for a situation like this. The merger of the two images created a stronger and realistic result (above).

Original image of elk: Pentax 6 x 7; 200mm lens; Fuji Velvia

Original image of sky: Pentax 6 x 7; 45mm lens; Fuji Velvia

BEYOND REALITY

Photoshop is a great tool to accomplish images that only your imagination can visualize. Death Valley is such a surreal landscape that I wanted to create an image that exaggerated this theme. I don't normally use Photoshop to go to these extremes as I like the final result to look as natural as possible, but on this occasion I couldn't create the look that I wanted in a straight shot.

The Racetrack is a mudflat where rocks seem to move of their own accord, leaving long trails behind. This phenomenon is explained by gale-force winds blowing the rocks across slick mud when the mudflat is saturated during a rainstorm. I wanted to create an image that made the rock appear to be possessed with great energy. During the original exposure, I lit the rock to give it some lift from the mudflat. Then, in Photoshop, I made a mask for the rock, allowing me to select the whole image except for the rock. I increased the contrast to make the cracked mud stand out more and removed the colour cast. I then wanted to make the rock appear to be emitting light so, after adjusting colour and contrast, I cloned the colour from the rock and extended it beyond its edges with a light and soft-edged brush tool, creating a gentle glow.

In addition to adjusting the colour and contrast of the rock, I decided to correct the uneven polarization in the sky (an effect often produced by polarizing filters when used with a wide-angle lens) by choosing a colour from the existing sky and then creating a smooth and even colour gradation from it.

This has moved beyond what could be called enhancement of the original photograph. It is really a digitally created 'fantasy' picture, but it goes to show the tremendous options that are available today in controlling and manipulating photographs, from simply allowing a long exposure or fitting a filter to the infinite possibilities of digital manipulation.

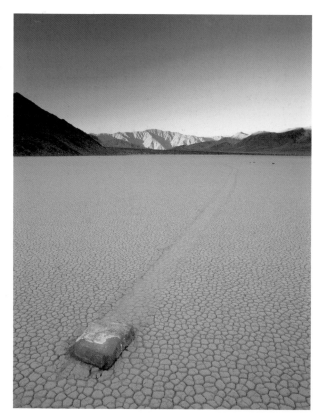

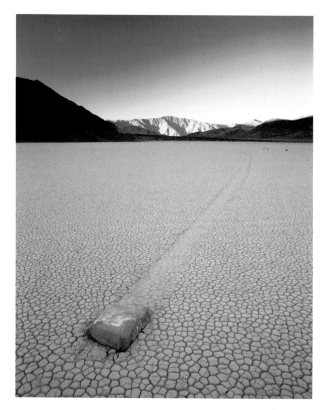

The Racetrack, Death Valley National Park, California, USA

In the pre-dawn light I lit the rock with a high-powered torch for the original image (left, above) to give it a boost. I used a polarizing filter to enhance the sky, but the result was uneven. In Photoshop I increased the contrast in the mud flat and removed the blue cast (left, below). Finally, I added the glow to the rock and evened out the polarization in the sky (opposite). Pentax 6 x 7; 45mm lens; polarizing filter; Fuji Velvia

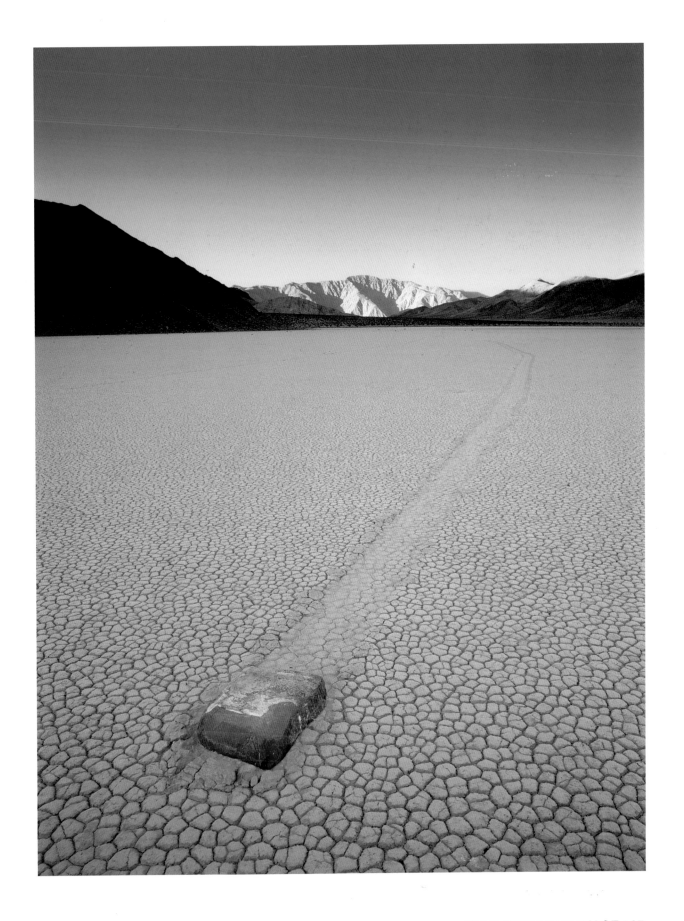

equipment

CAMERAS AND LENSES

I don't consider myself to be an equipment junkie. I think I have just the right amount of equipment to do the job. Saying this, I don't like to be confined to one particular format. Some scenes work only as a panoramic and the Fuji GX617 panoramic is ideal, because it has the quality of medium format and the versatility of interchangeable lenses. I prefer the 90mm and the 180mm lenses, although 105mm and 300mm lenses are also available.

I have found that one camera system may not completely fill my needs for a particular photo shoot. When I'm travelling abroad shooting stock images, I find that the Pentax 6 x 7 Mk II system gives me the speed of use and a good range of lenses, of which I use the 45mm, 75mm shift, 135mm macro and the 200mm. There have been occasions when I could have used a longer telephoto, but I wouldn't be able to justify the extra equipment if it is rarely used, and besides, my knees can't take any more weight.

Fuji GX617 panoramic fitted with the 180mm lens

Although I do enjoy using the Fuji GX617 panoramic and Pentax 6 x 7 cameras, my favourite is the Wista Field 4 x 5 rosewood camera. My training as a commercial photographer introduced me to the 4 x 5, which is a view camera (see also page 76), and it's the quality and complete control over the image that it gives that enticed me to use it in my landscape and architectural work. It's not a camera that facilitates quick, spontaneous pictures, though. Everything about it is slow. Setting it up, composing, exposure calculation, lens speed and changing film are all time-consuming procedures. Even viewing the image on the ground glass is not convenient either as it is upside down and backwards. So why do I even bother using it, especially in an age when a high percentage of images that are sold through libraries are digitized?

The Wista Field 4 x 5 camera is compact, lightweight and has versatility of movements that give complete control over the perspective and focus of the image. Because it has to be mounted on a sturdy tripod, using the 4 x 5 slows down the picture-making process. Precise care has to be taken when adjusting the movements, or focus can be out in one part of the image. For this reason, I take more time in composing and pay more attention to exactly what elements are included in the frame. In a

Wista field 4 x 5

sense, I feel it improves my work because when I trip the shutter, I'm not looking through the restricted view of a viewfinder, so I have to be aware of all the elements that might interplay with the scene. This might include people walking into the frame or any movement from tree branches or foliage in the foreground that would become a blur during a long exposure. Finally, a majority of the clients that I deal directly with still prefer to use 4 x 5. Images that I to supply other libraries have been a mixture of anything from 35mm to 4 x 5.

Large-format lenses tend to give optimum results with apertures of f/16 and smaller. They are not designed to be used wide open as the sharpness deteriorates. The smaller the aperture, the longer the exposure becomes and this is why any movement becomes crucial. The lenses I use with my field camera are the Nikkor 75mm, Schneider 90mm, Schneider 150mm and Nikkor 210mm.

Pentax MkII 6 x 7 fitted with a speedgrip and 45mm lens.

Some locations and subjects cry out for large format, so in these cases I pack the Wista Field 4 x 5 along with the Fuji panoramic. Because neither of these cameras has a meter, I take a Pentax V spot meter to determine exposures.

TRIPOD

A sturdy tripod is important no matter what format you use. Because I have to mount my camera on a tripod, I take more time to make sure the composition is exactly the way I want it, whether I'm using a 35mm or medium-format camera. I'm less likely to take snapshots randomly or include elements that creep into the frame by mistake.

I find that the Manfrotto 455B tripod with the Manfrotto 168 ball head is light enough for long hikes, and yet sturdy enough to suit the three different formats that I utilize. When I started using the Pentax 6 x 7, I ran into problems with vibration when using the 200mm lens in a vertical position on a pan-and-tilt head. Every image was soft. After speaking to several other photographers that use the Pentax I discovered I was not the only one experiencing this problem. I was told to try a ball head. I was hesitant, never having used one before – the thought of my camera moving freely in any direction on a ball didn't give me confidence in stability. But, after trying the ball head with the Pentax in a vertical position with the 200mm lens, my problem was solved. Now I find the ball head so quick to use that I would never use anything else. The quick-release plates take the hassle out of setting up and quickly changing from one camera to another.

There is one feature that would make setting up the tripod easier. This is a quick-release lever to drop all of the legs at once. I used to have a Manfrotto studio tripod for my commercial work that had this facility, but the tripod was much larger and heavier. I would love to have this feature on my current tripod. I have made one addition to my tripod: I've taped plumber's foam pipe insulation to each of the legs, which makes it more comfortable when I'm carrying the tripod over my shoulder, and it keeps my hands from freezing up on those cold winter mornings. You can buy a purpose-made product that looks nicer and serves the same purpose, but costs considerably more.

I adapt my backpack according to the location I plan to photograph. I always take the Fuji GX617 panoramic, and when I'm traveling abroad I also pack the Pentax 6 x 7. This allows me the versatility and quickness of getting travel pictures. On occasions where tripods are not allowed, I can hand-hold the Pentax or support it on my bag for long exposures. I also have the Pentax V spot meter to determine exposures when using the Fuji panoramic and as a backup to double-check readings from the Pentax TTL penta prism finder, although it tends to be very accurate.

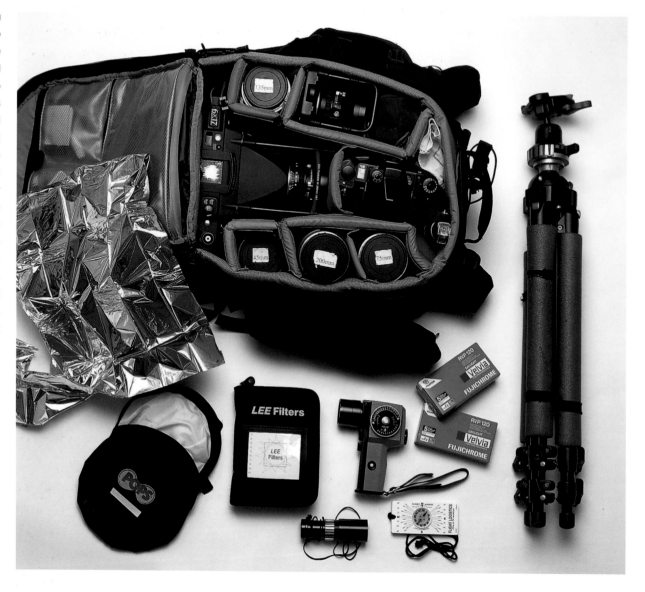

FILTERS

When it comes to using filters I try to steer clear of the gimmicky effects that some filters produce. There is no point using a filter where the effect overshadows the subject in the image. However, this is not to say that I won't use a filter to enhance the scene when needed.

The filter that I tend to use the most is the polarizer. I use a Tiffen ultra-thin polarizer for the 75mm Nikkor lens to avoid vignetting. If I want to use a couple of other filters, such as an neutral-density grad and a warming filter, together with a polarizer I will use the Lee 105mm rotating polarizer that fits to the front of the holder with an adapter ring. This enables the polarizer to be rotated independently of any grads that might be used.

I also use the ND grads, blue grad, coral grads, and warming filters. Though the range of Lee filters is extensive, they are also willing to produce a custom filter if it can be done. The only Cokin filter that I use is the 173 yellow/blue polarizer (see page 122).

I prefer using the 100 x 150mm Lee filters as they provide more than enough coverage for the various lenses that I use on the three different formats. I've had problems when using smaller filters. For example, if I want just a little of the feathered edge of the grad to come into the top of the frame, when I'm using a wide-angle lens the bottom of the filter comes into the frame because the feathered gradation starts in the centre of the filter. Using the 100 x 150mm filter system ensures that I overcome this problem.

CAMERA BAG

To carry all this gear I use the Lowe Pro Photo Trekker AW backpack. It is comfortable to wear, distributes the weight evenly on my back, and it's accepted by most airlines as carry-on luggage, which is vital when photographing abroad. It has a waterproof cover that works well if I get caught out in the rain or if I need to set the pack down in snow or on wet ground.

FILM

I find that Fuji Velvia, with its fine grain and deep saturated colours, helps me to accomplish impact in my photographs. Velvia has become the standard with landscape photographers. When I go on a 2-week photo shoot, I generally take at least 100 rolls. When I use the Wista, I will take 200–300 sheets. If I travel abroad with the Wista I need to conserve space and weight, so I will take the Fuji Velvia Quickload with the Quickload holder. These are individual sheets contained in their own envelopes, very much like a Polaroid. Using Quickloads saves having to carry a large number of heavy film holders;

after a long day of photography, the last thing I want to do is unload and reload film holders.

I have found that rating Velvia at 40 ISO instead of 50 gives the best results with respect to the process that I use. Processing can vary from lab to lab. Some can produce warm or cold results. It's always best to run a test by photographing a person holding an 18% grey card and colour chart (obtainable at most camera shops). Expose several rolls of film with the person holding a note of the f-stop used on each exposure. Send the film to several different labs to be processed. After seeing the results, choose the lab that gives the best results according to skin tones and colour. You can then determine which exposure gives the best results and increase the exposure by adjusting the ISO.

ACCESSORIES

There are a few accessories that I find essential to include in my backpack. Apart from the necessary lens-cleaning fluid, brush and tissue, I keep a large bin bag for kneeling on wet ground, large zip-lock bags to enclose lenses and bodies when shooting in wet or sandy conditions, a space blanket that can be used as a reflector or to lie on for low angles in wet conditions, spare batteries, and a whistle in case I get into trouble and have to raise the alarm, or scare off the odd bear.

When I want to determine where the sun will rise or set at any particular time of the year anywhere in the world, I use the Flight Logistics sunrise and sunset compass by Logistic Locations. For diffusing harsh sunlight when doing close-up work, I use a collapsible diffuser. Lastly, I keep a good wad of Blu-Tac stuck to my tripod in case I need to stick something together. I use it mainly to hold filters to the 90mm lens on the Fuji GX617 panoramic because the filter holder will not fit between the safety bars on the lens.

index

acknowledgements

I would like to thank the following people for their help in producing this book:

My editors at David and Charles, Freya Dangerfield and Neil Baber. I am immensely grateful for your guidance and expertise in putting together my first book.

Kate Salway, for her insight of photography and making my words coherent.

My copy editor, Jane Simmons, for adding consistency and questioning details that might seem obvious to me, but not to everyone else.

Kevin Allen, Edmund Nagele and Keith Neale, for providing endless advice and different perspectives on manipulation techniques.

My good friend, Les McLean, who is not afraid to give me constructive criticism.

And finally to my wife, Kim and my children, Jessie and Brandon, for allowing me to spend countless hours huddled away in my office to work on the book.